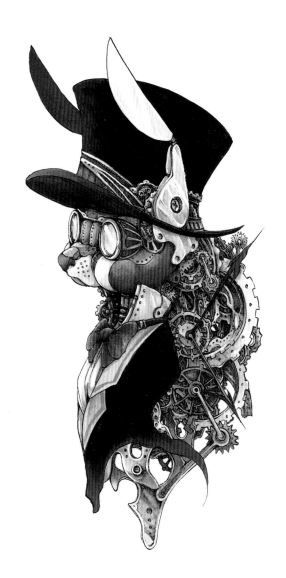

It's Possible to Render
Eye-catching Textures with

COPIC Markers!

Gallery

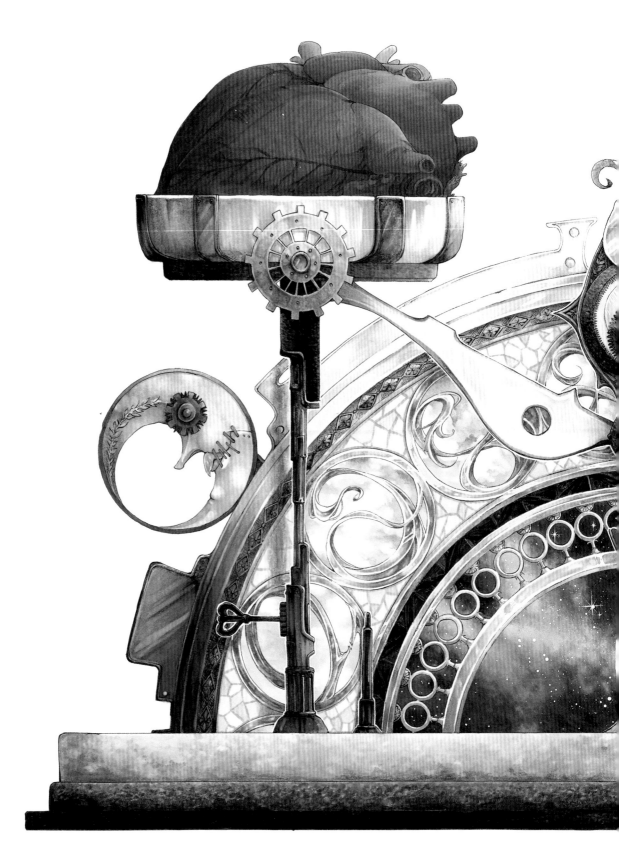

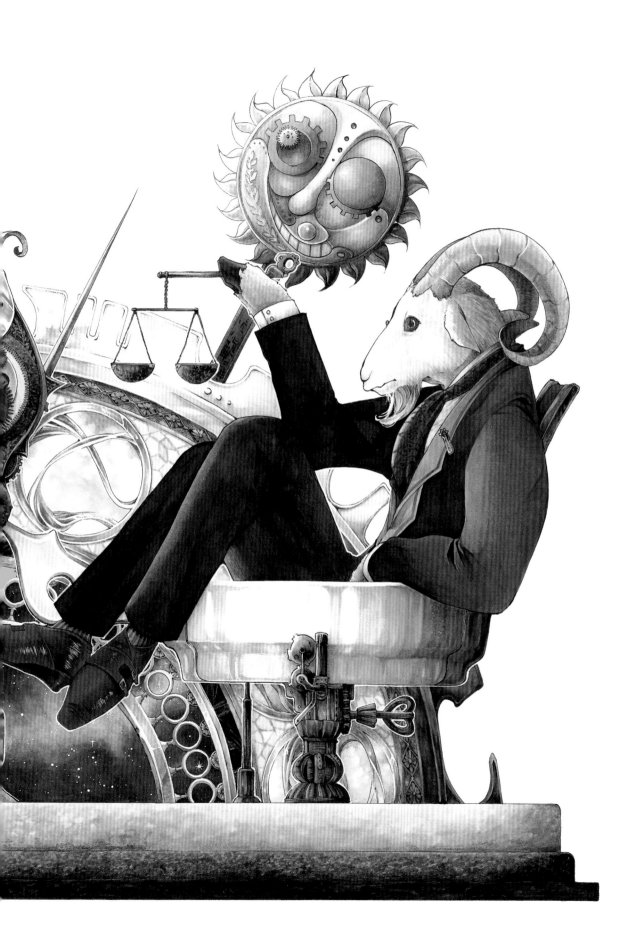

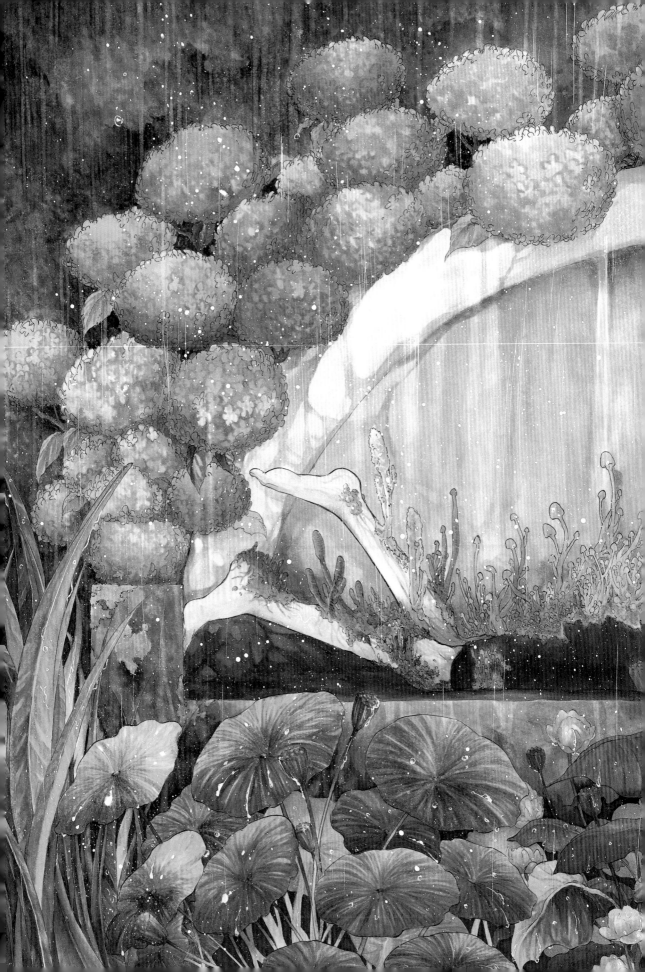

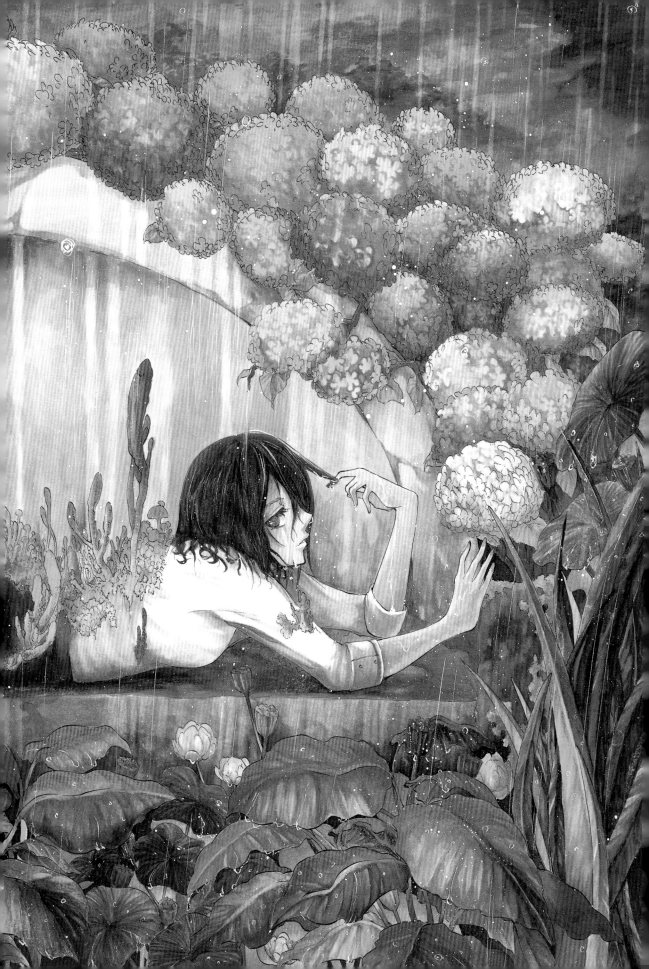

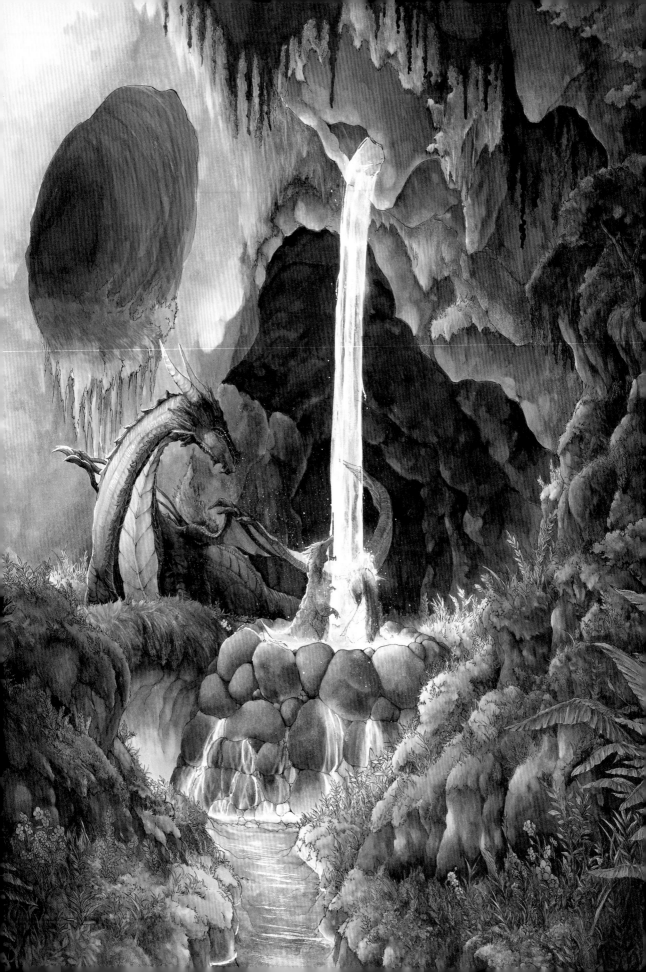

Index

Gallery..2

ARTWORKS...9

Basic Lessons...29

 Understanding COPIC Markers30

 Understanding COPIC Marker Colors.......................34

 Mastering the Basics of Coloring
 with COPIC Markers ..36

 How to Color with Gradation................................40

 Coloring with Gradation Using
 Different Color Schemes......................................42

 Gradation Samples ...44

 Textures Rendered Using Five Colors
 and Their Key Points ...46

Drawing Steps..51

 Scene 1: Contract with the Devil ·············52

 Scene 2: Dragon88

 Scene 3: Caterpillar Fungus116

 Scene 4: Dancer138

Appendix

 COPIC Sketch Color Samples on Kent Paper..........152

ARTWORKS

Yasaiko Midorihana

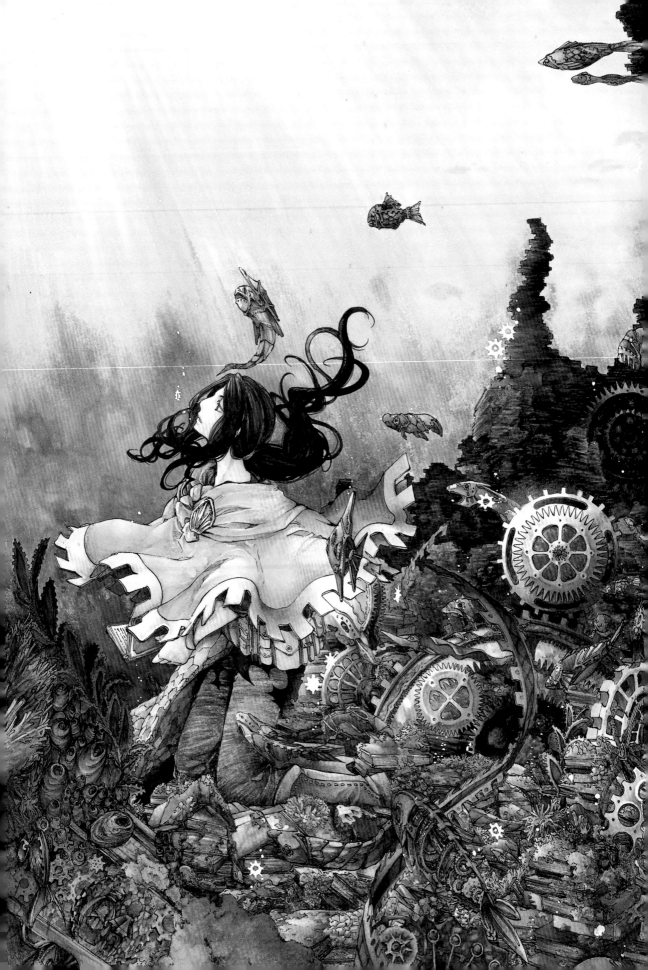

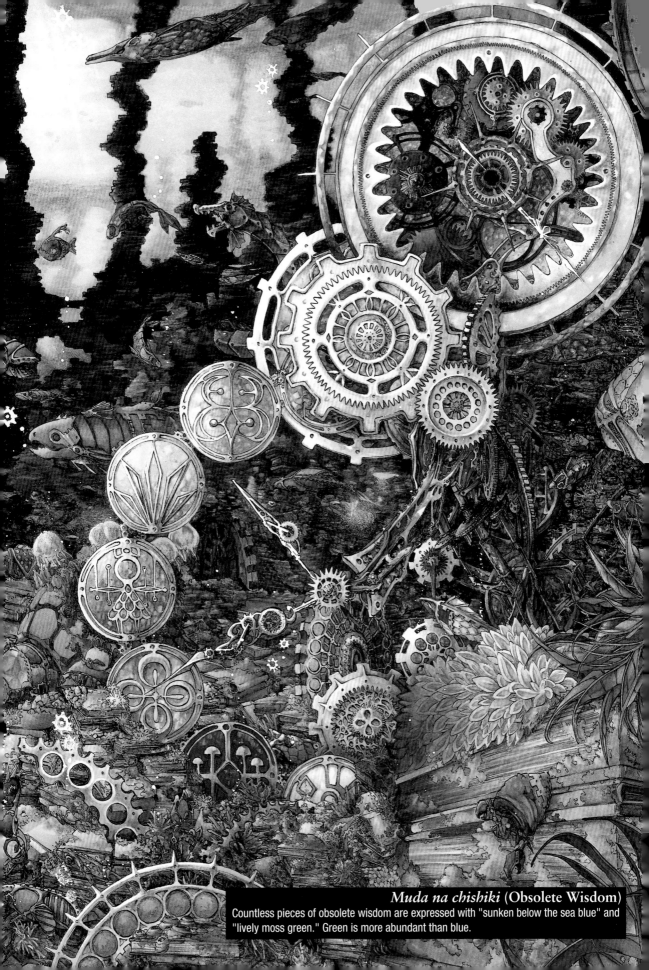

Muda na chishiki (Obsolete Wisdom)
Countless pieces of obsolete wisdom are expressed with "sunken below the sea blue" and "lively moss green." Green is more abundant than blue.

Hacchi

A drawing where I challenged myself to render shadows in green. Also, I attempted to render deer and horse skin textures.

ROCK, Vol. 1 Special Postcard
I chose to give the impression of light here because I didn't want to use too many dark colors.
My intention here was to produce a certain amount of background clutter so that I could paint
without first sketching every single cog and wheel.

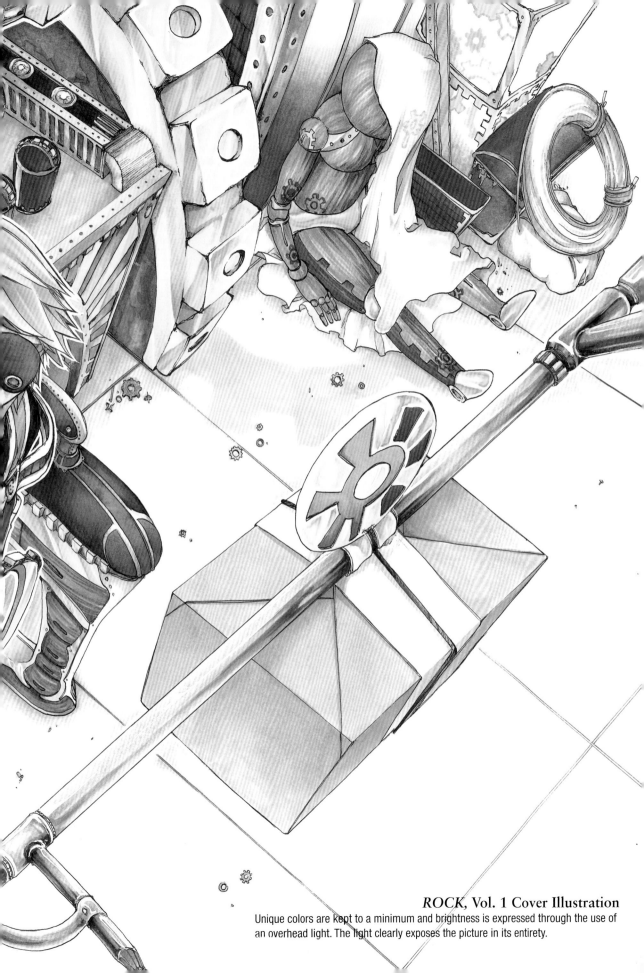

***ROCK*, Vol. 1 Cover Illustration**
Unique colors are kept to a minimum and brightness is expressed through the use of
an overhead light. The light clearly exposes the picture in its entirety.

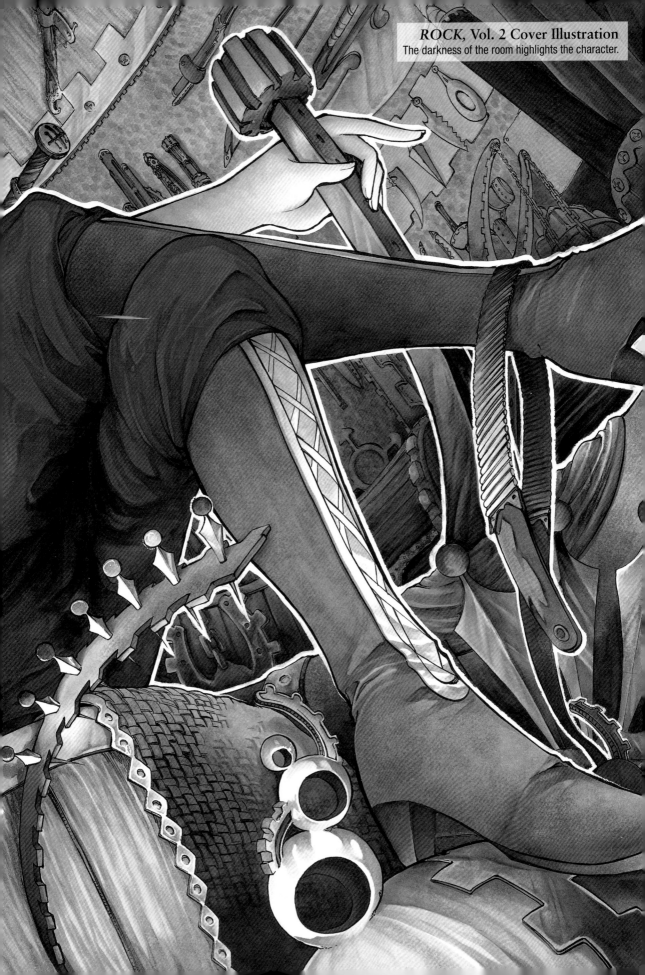

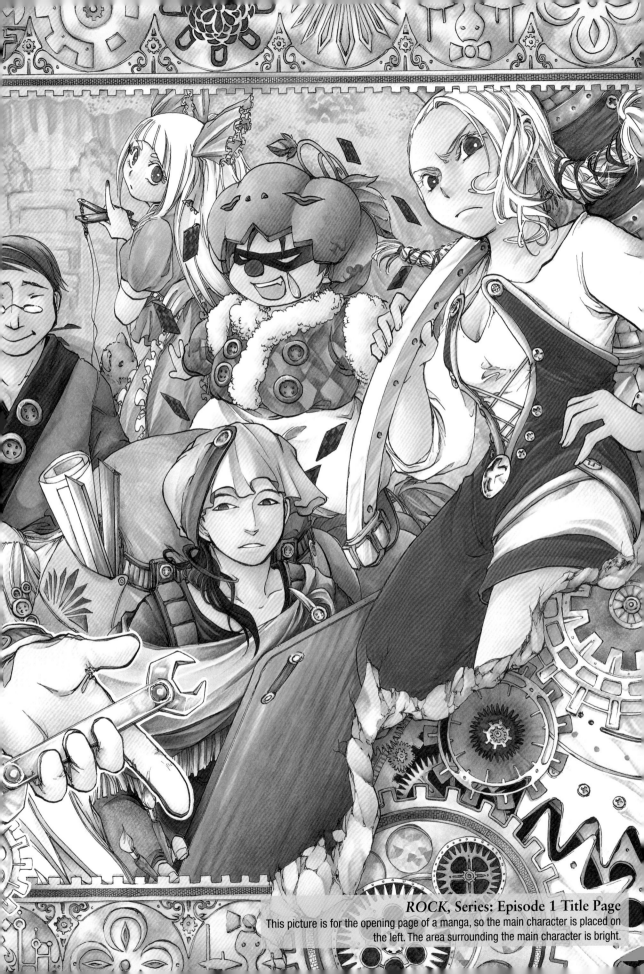

ROCK, Series: Episode 1 Title Page
This picture is for the opening page of a manga, so the main character is placed on the left. The area surrounding the main character is bright.

***Sakagurahime* (Sake Brewery Princess)**
In order to create the impression that the tree in the forefront is bleeding, a dark color is thinned with a very pale color to create a lighter red. In this case pale BV and the much darker R are quite compatible.

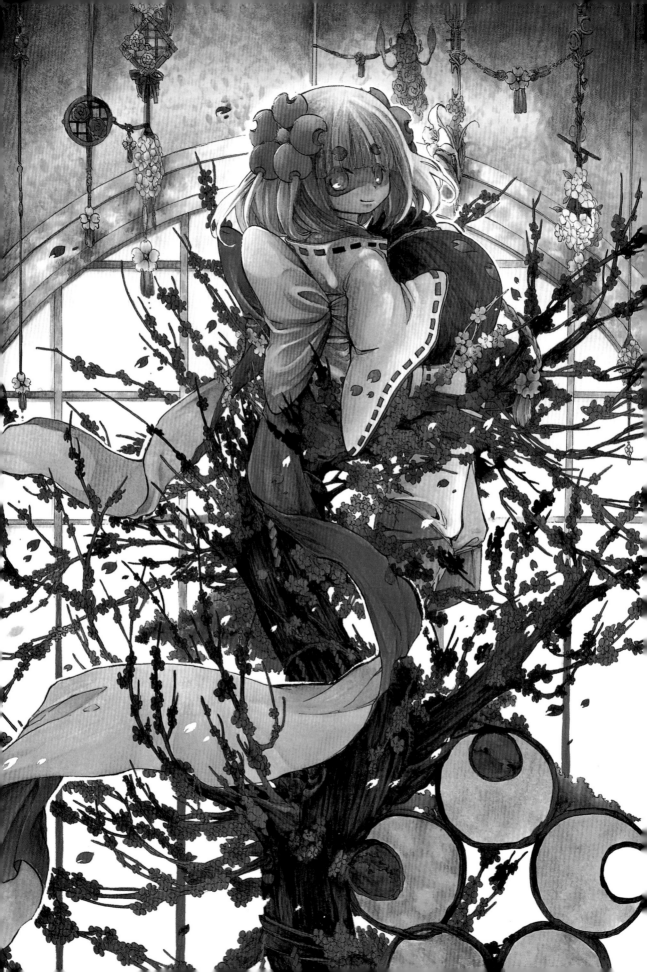

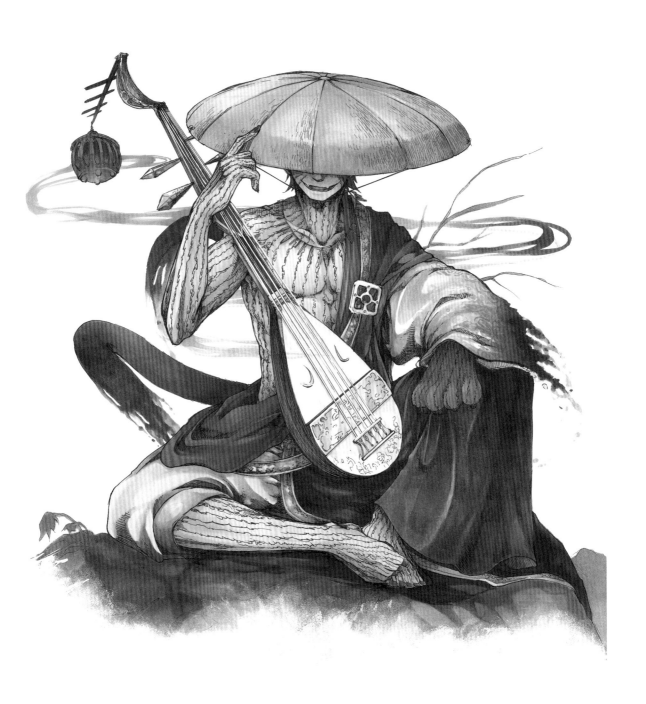

Bakeneko (Goblin Cat)

Colors are used to create a venomous feel. Red and magenta, along with yellow-green, create a
more venomous feel. At the bottom we use undiluted white ink to create a "scratched" effect.

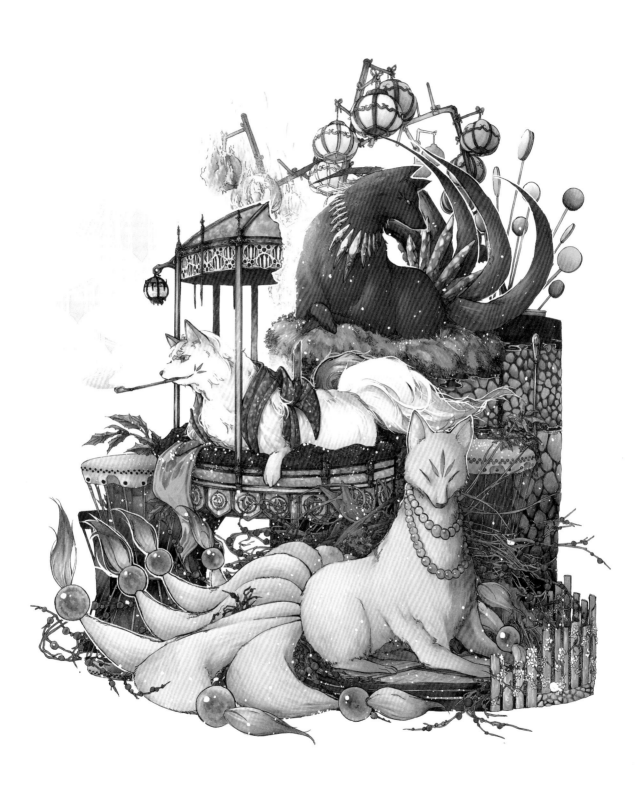

Fuyuyama (Winter Mountain)
Each coat of fur is painted differently. From the top down we have: hard, soft, and regular fur. The degree of curve in the furs create the difference.

Issho ni asonde kurerunokashira? (Will You Play With Me?) © Team Shanghai Alice
Darker shades of the chosen colors are used to create shadows and bring out the wildness of the character. By contrast, the stones are brightly colored.

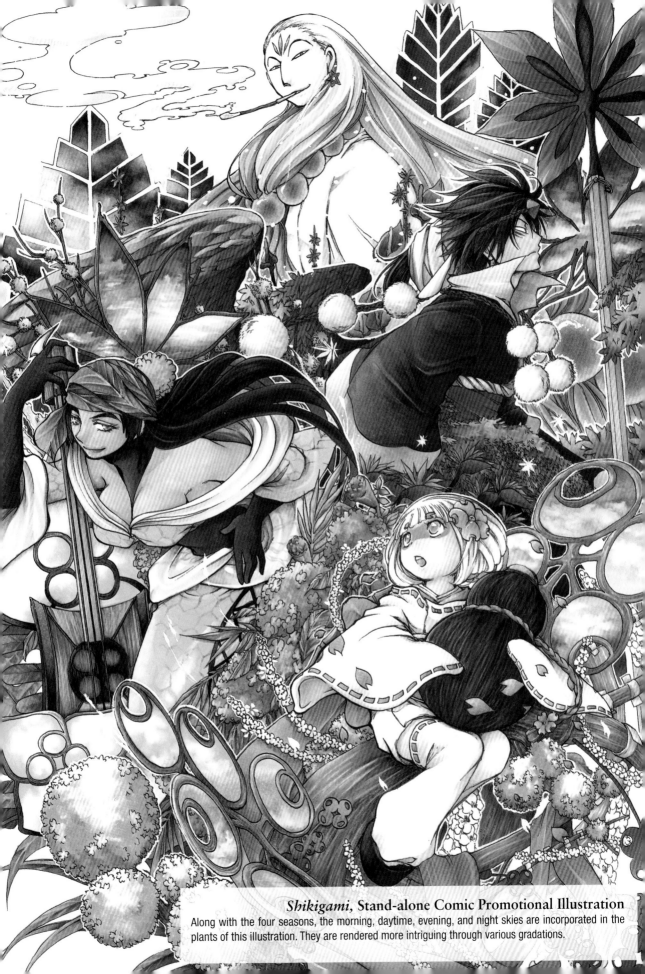

Shikigami, **Stand-alone Comic Promotional Illustration**
Along with the four seasons, the morning, daytime, evening, and night skies are incorporated in the plants of this illustration. They are rendered more intriguing through various gradations.

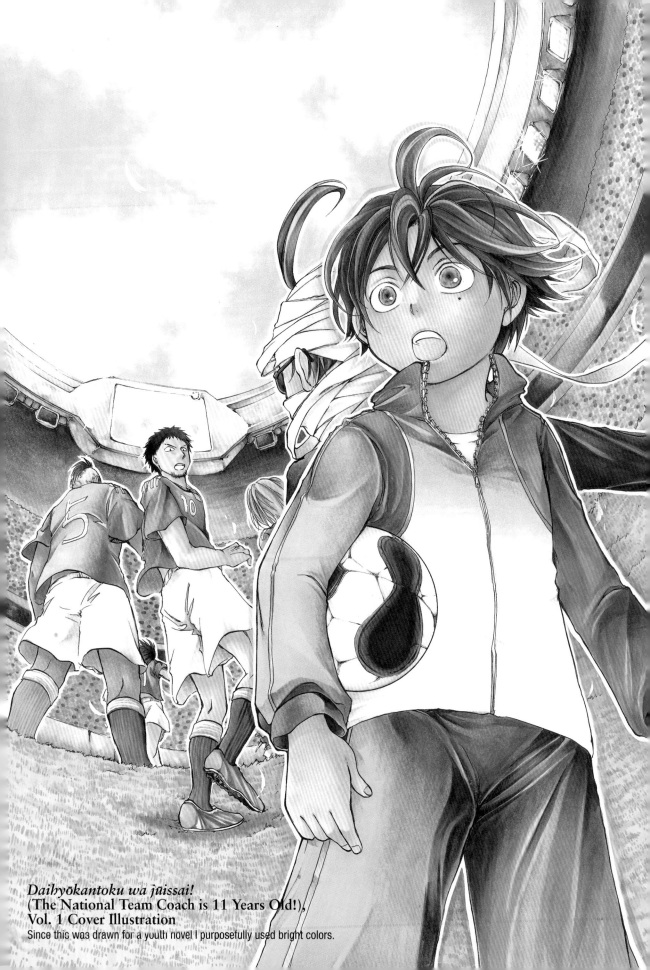

Daihyōkantoku wa jūissai!
(The National Team Coach is 11 Years Old!),
Vol. 1 Cover Illustration
Since this was drawn for a youth novel I purposefully used bright colors.

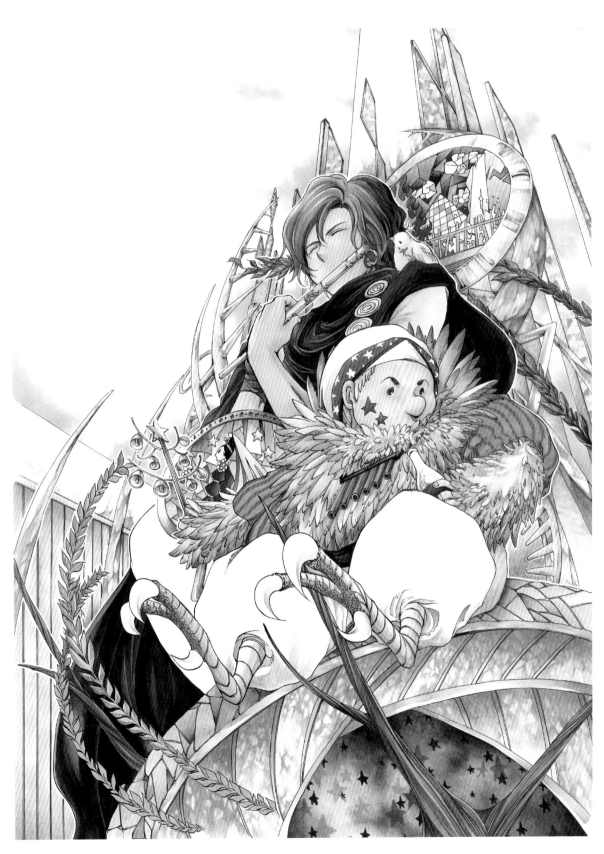

Mateki (Magic Flute), Cover Illustration
This pale colored illustration will appear flat unless you add in some wild colors

Source

Original Illustration
Year: 2014

Original Illustration
Year: 2014

Original Illustration
Year: 2014

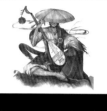

Original Illustration
Year: 2014

Promotional Postcard
Year: 2012

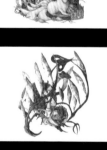

Original Illustration
Year: 2014

ROCK 1
Shōnen Sunday Comic
Book, Year: 2012
*Pen name: Hidekazu Gomi

Fan Art
Year: 2013

ROCK 2
Shōnen Sunday Comic
Book, Year: 2013
*Pen name: Hidekazu Gomi

Original Illustration
Year: 2011

Weekly Shōnen Sunday S,
June 2012, Shōgakkan
Year: 2012
Pen name: Hidekazu Gomi

Daihyōkantoku wa jūissai! (The National Team
Coach is 11 Years Old!), Episode: *Dōshite boku
ga kantoku ni?* (Why Did I Become Coach?)
(Shūeisha Mirai Bunko) Author: Giguru Akiguchi,
Illustration: Burokkori-ko, Year: 2011
*Pen name:Burokkori-ko

About: Yasaiko Midorihana

Her alias is burokkori-ko. Actively working as a manga
artist and illustrator. For boys manga she uses the pen
name Hidekazu Gomi.

Mateki (Magic Flute) (YAMAHA Music
Media) Manga: Brokkori-ko, Supervision:
Kyoko Nakano
Year: 2011
*Pen name:Burokkori-ko

Basic Lessons

Understanding COPIC Markers 30

Understanding COPIC Marker Colors....................... 34

Mastering the Basics of Coloring
with COPIC Markers .. 36

How to Color with Gradation 40

Coloring with Gradation Using
Different Color Schemes ... 42

Gradation Samples .. 44

Textures Rendered Using Five Colors
and Their Key Points ... 46

Understanding COPIC Markers

COPIC is a registered trademark of Too Corporation, Japan.

Medium Broad Nib
This end is hard. Similar to regular marker pens, the nib is firm and useful for roughly filling in large areas.

What Is a COPIC Marker?

COPIC markers are alcohol-based ink pens. They are developed and manufactured by Too Marker Productions Inc. Like regular marker pens, COPIC markers have superior quick-drying properties and produce excellent colors. This allows you to quickly and beautifully color almost anything. Moreover, COPIC markers offer an abundance of colors. Actually, the "COPIC Sketch" markers used in this book come in the widest range of colors. 358 colors to be exact. By blending and overlaying colors anyone can create their own *original* shades of color. This enables anyone to render realistic textures and to produce a huge variety of expressions. All of this means that COPIC markers are extremely popular among professional illustrators and manga artists.

Excellent color!

Dries fast!

COPIC markers alone do the job

Points of Caution

COPIC markers use alcohol-based ink so they will dry out if you leave the cap off. Similarly, if the markers are stored at high temperature the ink will quickly dry out.

Also, be careful not to stain your clothes as the ink will not come off after it has dried. Pay particular attention when removing the cap as ink may splatter out onto your clothing.

Do not leave the cap off!

The ink is highly volatile, so be sure not to store your markers at high temperature.

Do Not Place in Your Mouth!

Super Brush Nib
This end is soft. Since the nib is flexible, like a paintbrush, it can emulate various brushstrokes. This book introduces methods for using the Super Brush nib.

What Is "COPIC Sketch"

Among all COPIC products it is the Sketch markers that offer the widest range of colors. They are therefore quite well suited for illustrating. The tip of the COPIC Sketch marker is called a nib, and comes in two different types. In order to achieve the desired effect you must learn to use each nib correctly.

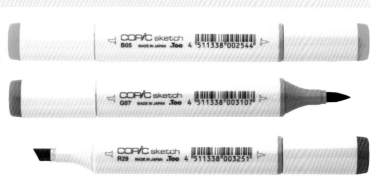

When the tip of the nib appears white, the ink is almost gone.

What Other Types of COPIC Markers Are There?

Besides COPIC Sketch, there are two other types of COPIC markers. One is the "COPIC Ciao." This is the most economical option and offers 180 colors that are specifically selected for COPIC beginners. The other type is the "COPIC Classic," which are quite well suited for design drawings.

The name "COPIC" comes from the fact that its ink will not dissolve copier toner. Prior to COPIC the majority of markers dissolved copier toner when coloring over a copied picture.

Using the Super Brush Nib Properly

When you use COPIC markers you are not restricted to simply "coloring." You can also do plenty of "drawing." The Super Brush nib demonstrates its strength when drawing. You can conveniently create a variety of brushstrokes, regardless of the thickness of the line.

Draw Thin Lines by Angling the Tip of the Pen

This method is useful for rendering textures by coloring using dots or drawing lines. You can also add flow, like that found in one's hair, to most any object. The nib is angled throughout this book, except when coloring large areas.

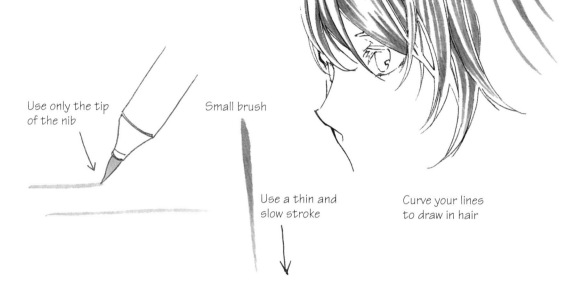

Use only the tip of the nib

Small brush

Use a thin and slow stroke

Curve your lines to draw in hair

Creating a Medium Brush Stroke by Slightly Tilting the Nib

You can draw lines that range in thickness from thin to medium depending on how much pressure you apply to the nib. This can be useful when evenly filling in large areas.

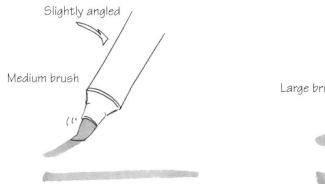

Slightly angled

Medium brush

Boldly Angling the Nib and Using the Side of the Marker

This method is not used much in this book. However, it should be noted that you can easily draw thick lines by aggressively angling the nib.

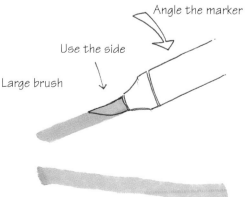

Angle the marker

Use the side

Large brush

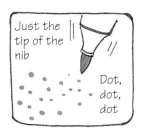

Just the tip of the nib

Dot, dot, dot

Sample dotting effect

Rendering unevenness

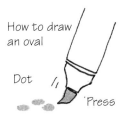

How to draw an oval

Dot

Press

A riverbed seen from a distance or perhaps a goldfish tank?

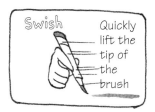

Swish

Quickly lift the tip of the brush

How to Hold Your COPIC Markers

There is no "absolute correct way" to hold COPIC markers, but I think it is best to hold them in a manner that allows you to easily control pressure.

I recommend "*gūpan* style" (see picture) if you find it difficult to draw a thin line or for those who find that "pencil style" (see picture) produces an uneven finish due to pushing too hard on the marker.

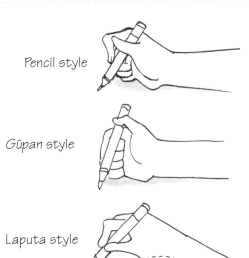

Pencil style

Gūpan style

Laputa style

Lift

Understanding COPIC Marker Colors

Color Family

The letter represents the color family. There are sixteen categories.

Brightness Value

Color brightness is broken into twelve categories.

Color Saturation

Each color family is divided into ten levels of color saturation, labeled 0 through 9.

Color Name

Individual name

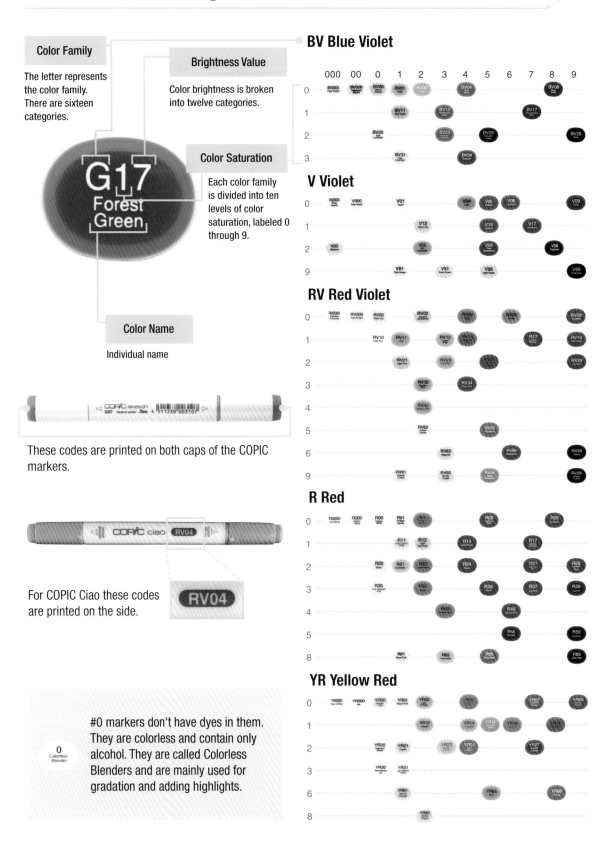

These codes are printed on both caps of the COPIC markers.

For COPIC Ciao these codes are printed on the side.

RV04

#0 markers don't have dyes in them. They are colorless and contain only alcohol. They are called Colorless Blenders and are mainly used for gradation and adding highlights.

0
Colorless
Blender

BV Blue Violet

V Violet

RV Red Violet

R Red

YR Yellow Red

COPIC markers offer 358 colors categorized in sixteen color families. Each color is numbered by color family, color saturation, and brightness level. This makes it easier to figure out which color you want.
This section provides a color chart of all 358 COPIC Sketch marker colors.

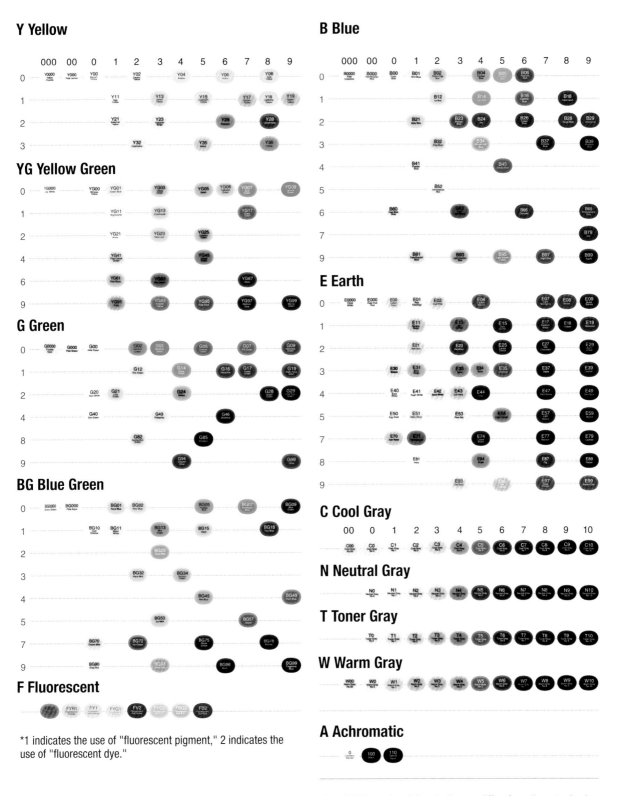

*1 indicates the use of "fluorescent pigment," 2 indicates the use of "fluorescent dye."

*Careful! The color of the plastic cap *differs* from the actual color of the ink in the marker.

Mastering the Basics of Coloring with COPIC Markers

Compared to other types of painting materials, COPIC markers are easier to handle precisely because they have the properties of a marker. On the other hand, to achieve a truly beautiful finish and to render various textures with markers we will require some tricks. This section explains the basics behind such tricks.

How to Create an Even Finish

If you are unfamiliar with COPIC markers, your attempts at painting a large area may leave an uneven finish. Don't worry, once you master certain tricks, you will be okay. In fact, there are different methods you can use to produce a smooth finish. So, be sure to choose the one that you find easiest to use or the one that best matches the shape and size of the area to paint.

Examples of an Uneven Finish

Pressing the tip of the pen down hard tends to create an uneven finish.

① Slowly paint using a medium-sized brush

Move the brush up and down, as if painting waves, and fill up a chosen area. Leave no gaps. Notice how this creates a slightly darker color.

② Paint as you move the tip of your pen in a circular-shape

Paint as you move the tip of the pen in small circles. It is okay to move your pen quickly, just pay attention not to jump too far off your intended line.

③ Paint twice

Lay the tip of your pen on the paper and broadly fill an area with up-and-down zigzags. At this point the unevenness is quite evident.

Over your initial lines fill the area again, stroking in a uniform direction, to conceal the unevenness. The only problem here is that the color is laid down twice so it becomes darker.

④ Use COPIC #0

Apply COPIC #0 (Colorless Blender) as a foundation.

Before it dries, apply your chosen color over the foundation. This makes it easy to apply and creates a uniform finish. However, the color will come out slightly pale.

How to Pick a Color

Just before you begin to apply color you might unexpectedly find yourself getting lost in the question of "which color should I choose?" Even though you may have decided on a particular color scheme of the overall picture, or at least a particular area, choosing specific colors can sometimes be troublesome. Firstly, begin by actually applying a single color. Then, decide on other complimentary colors so that you won't lose the overall feel of the work.

Trial

Decide on a base color

Try sketching something and then, while examining the sketch as a whole, think to yourself, "something akin to this color goes here, right?" The "something akin" can be a single color, and that's okay.

If attempting to grasp "the image" of your color is difficult, just make a copy of your sketch and start applying some approximate colors. Painting roughly will do here.

As shown above, you can decide on a general color scheme. Once a few basic colors are chosen you will be fine.

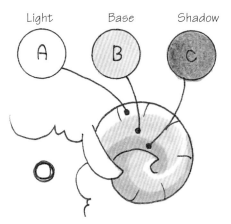

Light — A Base — B Shadow — C

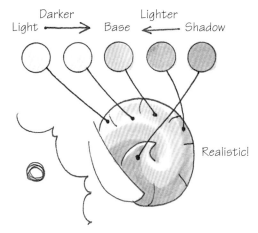

Darker → Lighter ←
Light → Base ← Shadow

Realistic!

Next you can decide on a precise color scheme. The basis for picking colors depends on light and shadow. Where light is cast, colors become lighter than your base color. Where shadows are cast, colors will become darker than your base color. That said, you should decide on colors A and C based on your initial choice of color B (see picture above).

You can create a beautiful painting just by using these three basic colors. However, you can create a more three-dimensional, realistic rendering by making intermediate colors out of the three basic colors. Alternatively, you can use a totally different color that might be associated with an object in the picture which will allow the overall color scheme of the picture to blend well.

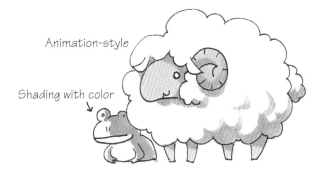

Animation-style

Shading with color

Aside from the methods listed above, we can try to paint animation-style by using a base color and a shading color, or by rendering with just one color and leaving areas of light unpainted, while heavily filling in certain areas to create shadows. These techniques can create interesting effects.

ow to Cast Light and Shadow

How shadows are cast varies on the direction of the light source and its strength. By thinking logically, and through habitual observation, rendering shadows should become quite natural. However, getting the hang of it takes a little while.

For reference purposes, this section provides samples of how shadows are cast from various directions.

Direct light	Backlight

Front upper right	Front upper	Front upper left
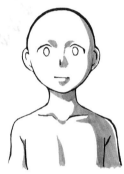		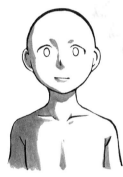

Right side	Both left and right	Left side
	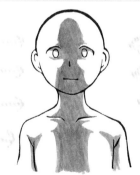	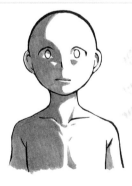

Front right bottom	Front bottom	Front left bottom
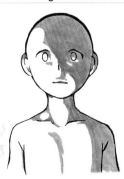	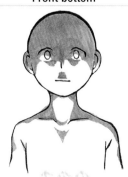	

Skin Tone Samples

Skin tone is important when it comes to drawing characters. This section will provide color combinations for four basic skin tones. In this particular example, men have yellow-ish complexions while women have red-ish complexions.

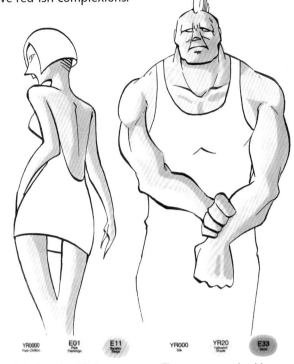

E34 Toast | E17 Reddish Brass | E47 Dark Brown

Brown skin tone appears red-ish, but red is not used.

YR20 Yellowish Shade | E34 Toast | E17 Reddish Brass

Tanned skin has a yellow color component.

YR0000 Pale Chiffon | E01 Pink Flamingo | E11 Barley Beige

Pale female skin tone appears faintly red, but again red is not used.

YR000 Silk | YR20 Yellowish Shade | E33 Sand

The average male skin tone has a strong yellow component.

Blending and Shading

Blending and shading are important techniques when creating intermediate colors. This section explains blending and shading using the colors BV11 and V09.

For blending first apply a base color.

While the base color is still wet, add a darker color and let it bleed.

For shading first apply a darker color.

Then, spread a pale color around the darker color to soften the edges.

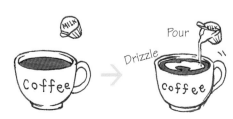

The closest image we can provide is pouring cream in your coffee

The closest image we can provide is that of a solid object melting into a liquid. Bleeding uses COPIC's ability as a "solvent."

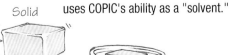

Solid

Soak in water

Melting

Jiggle

How to Color with Gradation

When rendering textures using COPIC markers the most important technique is "gradation." Mastering "gradation" enables you to draw clouds, fabrics, leather, water, and even metals. In this section, two methods of gradation are introduced. Both methods have their pros and cons. Use them on a case-by-case basis. Throughout this book, vertical gradation is often chosen. Five different color markers (G46/YG17/YG25/G43/YG11) are used for ease of understanding. No matter how many shades of colors you use in your gradation, one basic concept applies in all cases.

How to Paint Using Horizontal Gradation

This is a method for displaying a gradual color change by applying different shades of a chosen color in layers, while being sure that the "in-between" colors remain blurry.

Pros. Easy to paint. Convenient for making light and shadow distinguishable.

Cons. The layering is relatively evident. It is difficult to create a gradation when complementary colors are used. Gradation tends to create unevenness.

In ascending order, paint ① through ④. For a beautiful finish apply ⑤, and ⑤ alone from the bottom upward.

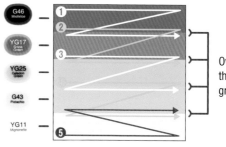

Overlapping colors in these areas creates gradation.

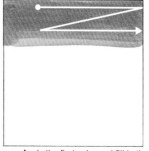

G46 Mistletoe — Apply the first color and fill in the area beginning from the top edge of the paper.

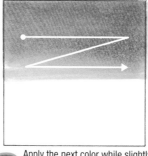

YG17 Grass Green — Apply the next color while slightly overlapping the first color.

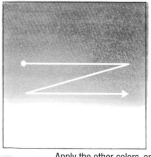

YG25 Celadon Green G43 Pistachio — Apply the other colors, one after another, in the same manner.

YG11 Mignonette — At the end of the gradation, apply the last color beginning at the bottom edge of the paper.

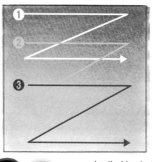

G46 Mistletoe YG25 Celadon Green YG11 Mignonette — Lastly, blend with the three colors listed under the photo to finish.

How to Create Vertical Gradation

This is a method that extends the foundation color by overlapping paler colors, one-by-one, downward.

Pros. There are no layers, and a beautiful gradation is created even when complementary colors are used. It is easy to create gradation along the entire painted area.

Cons. More difficult than horizontal gradation. Difficult to recover any mistakes.

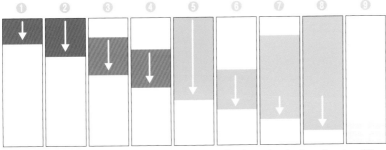

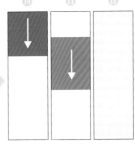

This diagram shows the positioning, and length of application, for each color. From the edge of the area overlap colors, as if extending the earlier color downward. Since the luminosity of the median color changes drastically, as seen in ⑤, apply that color all the way from the upper edge of the paper. Also, adjust the overall gradation by applying the second to last color, as in ⑧.

Lastly, be sure to blend the overall gradation using the colors applied to each edge and their intermediate color following the diagram above.

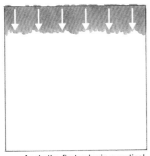

G46 Mistletoe — Apply the first color in a vertical direction from the top edge.

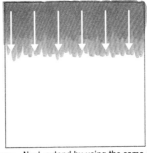

G46 Mistletoe — Next, extend by using the same color and starting at the top edge again. Paint down past the edge where you stopped. This darkens and blends the first color with itself.

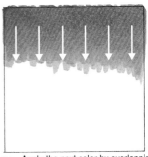

YG17 Grand Green — Apply the next color by overlapping it with the area you extended in the previous step.

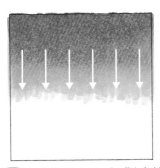

YG17 Grand Green — Lay down the next color (listed at the left) from about the middle of the second and third color to blend in your boarders.

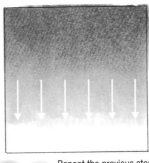

YG25 Celadon Green **G43** Pistachio — Repeat the previous steps to fill in the area shown.

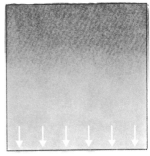

YG11 Mignonette — Apply the last color all the way from the top edge to the bottom edge.

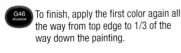

G46 Mistletoe — To finish, apply the first color again all the way from top edge to 1/3 of the way down the painting.

YG25 Celadon Green — Similarly, apply the intermediate color to the middle portion.

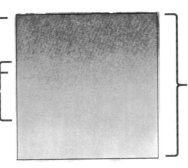

YG11 Mignonette — Paint over everything with the last color to blend and finish.

Coloring with Gradation Using Different Color Schemes

Gradation techniques are indispensable when rendering textures using COPIC markers. Even though you can successfully create beautiful gradations using similar colors, as seen previously, attempting to use different colors can result in a dull, washed-out, gradation. This section explains the proper method for creating beautiful gradations with colors that have different color families.

Chose Compatible Intermediate Colors

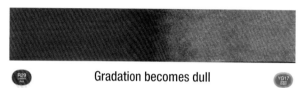

Gradation becomes dull

When you intend to create gradations with incompatible colors, adding a color that is compatible with both of your chosen colors enables you to create a beautiful gradation. In this particular example, yellow is compatible with both red and green.

For example, when creating a gradation where red gradually changes to green, without an intermediate color you will notice that the overlapping area becomes dull and black. The reason is that green is a complimentary color of red so they neutralize each other.

We achieved a beautiful gradation

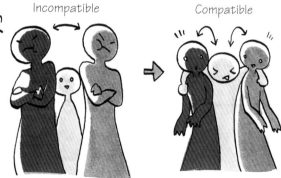

Incompatible Compatible

Red Yellow Green

How to Choose Intermediate Colors

Little tricks are necessary to properly choose intermediate colors. Let's take a look at an example using purple and yellow.

Since it is necessary to understand how colors are combined, let's briefly go over the three primary colors.

1: Cyan
2: Magenta
3: Yellow
4: Blue
5: Red
6: Green
7: Black

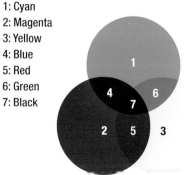

① Three primary colors

There are various elements that compose a color. It is well-known that mixing the three primaries can produce a variety of colors. "Primary colors of light" refers to the three primary colors of a luminous body, like a computer monitor. "Primary colors of pigment" refers to colors produced through the reflection of light, like in printing.

The primary colors of pigment are cyan, magenta, and yellow. Mixing them produces all colors except those that are achromatic, such as white.

2 Think about the compositional elements of purple

Let's begin with purple. Which of the primary colors makes up purple? Many of you will already know this. It's red and blue. Depending on the amount of red and blue you use, the resulting color is either going to be red-ish purple or blue-ish purple. This particular example ended up being blue-ish purple.

3 Think about the colors that are derived using yellow

Since yellow is one of three primary colors, there isn't a color combination that produces yellow. So it is best to think about which colors yellow can produce through mixing.

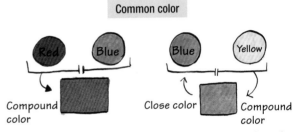

Common color

There are many more examples like this, but the important thing for us right now is to find the common color in "color combinations that produce purple."

For blue-ish purple, the common color is blue. Based on this, let's create some gradations.

4 Assembling the base

After sorting out the composition of each color element, let's create a gradation. The basic concept is shown below.

Purple disassembled

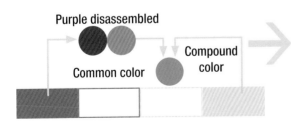

Common color · Compound color

① Purple can be disassembled into red and blue, and blue is the color combined with yellow to produce green. So, blue is the common color that purple and yellow share.

② In between the common color (blue) and yellow, we find green. We know that green is the product of yellow and the common color (blue).

This sample gradation uses FV2 through Y13. I used B45 for blue and G02 for green. YG25 is used for yellow-green, which is an intermediate color between green and yellow. Using these five colors creates a smooth gradation.

Gradation Samples

Darker to Paler Samples

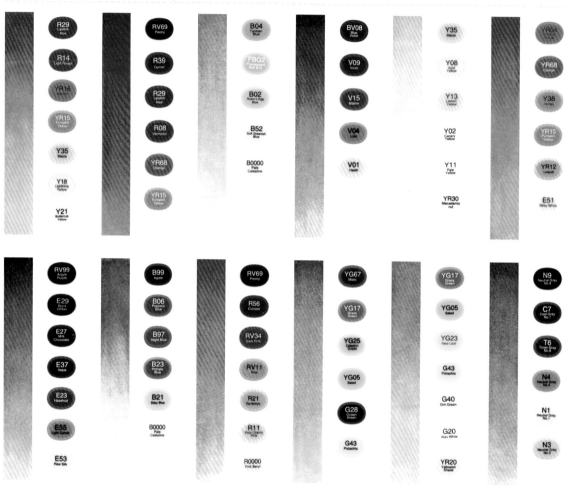

Varying Shade Samples

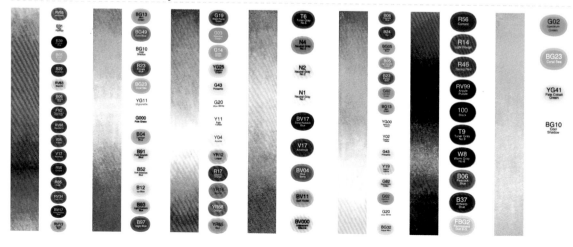

These are gradation samples. Aside from dark to pale color gradations we find gradations of a variety of other colors and even textures. Once you master gradation techniques it is possible to render a variety of textures like in the examples below.

Texture Rendered with Gradation

Wood (log) Horse skin Soft fabric/parchment Simple denim Oxidized iron

Water Flame Pastel The pupil of the eye Hair

Fabric Bubbles Mylonite Feathers Night sky

Textures Rendered Using Five Colors and Their Key Points

Now, since you have already discovered the general use of gradation for rendering textures, this section will present the key points for rendering those textures using more detailed examples. Rendering a texture often requires many colors, but that is not always the case. Eight different basic textures, most likely to be required when drawing, are chosen in this section. You can render each texture using only five colors. Key points for drawing are also included. Please refer to them for your own projects.

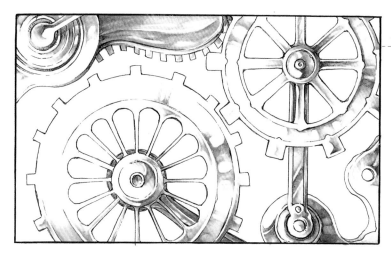

Silver Cogwheel

BG0000
Snow Green — The color for bright areas. Used for light that is cast on the silver.

BV00
Mauve Shadow — In order to bring out the silver color, add pinkish-purple shadows.

C3
Cool Gray No.3 — Base shadow color.

W5
Warm Gray No.5 — Used for only the darkest shadows.

+ White

- The trick to rendering a metallic texture is to "draw variations of a capital 'I'."

- By adding each "I" in layers, your drawing will look more like metal.

- The key point here is to outline the shape of the "I." Also, making the center blurry brings about a more realistic feel.

When applying a color, begin with the pale shadow color (in this example, it's C3), and then the metal color (BV00) and base color (BG0000). Then, apply the darkest shadow color (W5). All the while be sure to think about the direction of your light source.

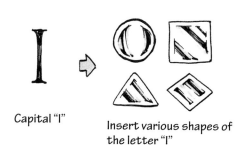

Capital "I"

Insert various shapes of the letter "I"

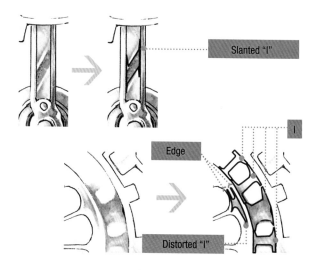

Slanted "I"

Edge

Distorted "I"

Fresh Green Leaves on a Tree

 Y02 Canary Yellow — The color of the brightest areas

 YG23 New Leaf — Sunny side base color

 G24 Willow — Shady side base color

YG17 Grass Green — Base color of the shadows themselves

YG97 Spanish Olive — The color for the darkest, deepest shadows

For the leaves on the tree the point of reference is the thickest vein at the center of the leaf, since that is where light is cast the most.

- From there, create a gradation towards the edge of the leaf. Then, add detailed shadows to the veins of the leaf to create a truly beautiful painting.

- Add your colors while paying close attention to where the sun shines and where it can't reach.

- Remember, the steps are: Base paint. Add shadow. Then add gradation.

Light
Gradation alone works quite well at a distance

Veins are rounded towards to the edge

Curve / Light

Veins become slightly more noticeable where the sun shines

Brick Wall

 E13 Light Suntan — Brightest part of the brick/grout shadow

 YR18 — Bright part of the brick

 E08 Brown — Base color of the brick

 V95 Light Grape — Bright part of the grout/shadow of the brick

 N4 Neutral Gray No.4 — Dark part of the grout/dark part of the brick

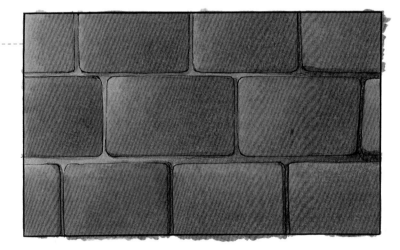

- First, you must think about the direction of your light source. Both light and shadow are cast on the edges of each brick. Create gradation diagonal to the light source in order to render the brick texture.

- Pay attention to the curves of the brick while painting. The gradation you add will vary depending on the angle of the curve.

Pay attention to the curve of the brick

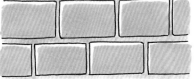

The coarseness of COPIC markers works really well for rendering the texture of brick so all you need to worry about is rendering light.

Light Permeating Rock

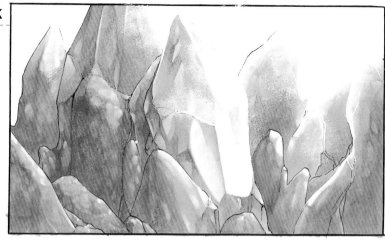

Y00
Barium Yellow — Brightest planes

YG41
Pale Cobalt Green — Base color

G02
Spectrum Green — Color for lighter shadows

BG15
Aqua — Color for shadows that are affected most

BG57
Jasper — Color for the darkest, deepest shadows

+ White

- Rocks are just rocks, but these are emerald green rocks that allow light to permeate like crystals.

- The basic concept for drawing rocks is to consider the overall shape and confirm the location of each of the following areas: brightest area, the area that shows the rock's color, the lightly shaded areas, and the areas in darkest shadow.

- While imagining how to place the shape of a diamond over the rock's surface, proceed to draw.

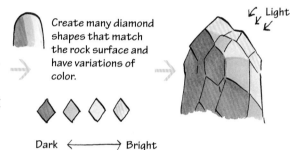

Create many diamond shapes that match the rock surface and have variations of color.

Dark ⟵⟶ Bright

Light

Stream of Water

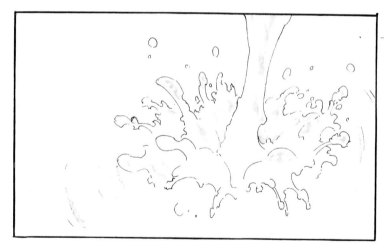

BG0000
Snow Green — Base color

B01
Mint Blue — Used for slightly shaded areas

B21
Baby Blue — Base shadow color

T2
Toner Gray No.2 — Used to accent shadows

0
Colorless Blender — Use to blend

- Similar to rendering metallic textures, the basic idea when painting water is to shade as if you were outlining an "I." However, water doesn't have a solid form like metal so this is going to be a little more difficult.

- Be sure to leave a clear gap between the outline of the water and the blue color of the water. If they touch, you will lose the illusion of transparency. Always try to draw water in this manner.

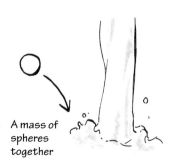

A mass of spheres together

If the lines are too straight, it doesn't look right

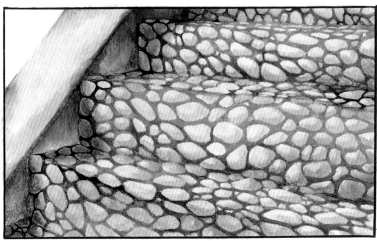

Stone Steps

BV20
Dull Lavender — Mainly used for the bright part of the stone

V20
Wisteria — Base color

BV23
Grayish Lavender — Mainly used for the shaded part of the stone

W5
Warm Gray No.5 — Mainly used for the bright part of the grout

N7
Neutral Gray No.7 — Mainly used for the dark part of the grout

Shadow is added only to the bottom → Side — It will look like this

Gradation → Side — It will look like this

- For all intents and purposes this is the same as drawing the bricks in a prior section. However, the shapes of the stones are not sketched. This allows for a more natural finish.

- After drawing your stones, draw in the grout. Doing so allows the colors to settle.

- Pay attention when you draw the stones. The way in which you add the shadows will change the appearance of the curves in the stone.

Fabric Flutters About in the Wind

RV21
Light Pink — Color of the bright area in the lace

RV34
Dark Pink — Base color for the plane under the lace

RV19
Red Violet — Base color for dark areas under both the lace and the dress

V09
Violet — The color for dark shadows

B79
Iris — The color for the darkest, deepest shadows

+ White

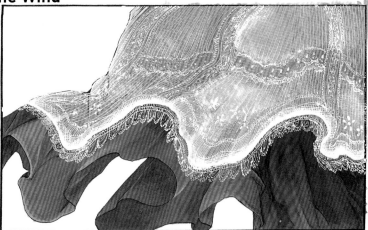

- Gradation techniques are also applied when rendering fabric textures. Rendering fabric may seem difficult. I think the reason for this is that adding shadows according to the shape of the fabric is quite tricky.

- I believe that you can master the techniques for rendering fabric textures by observing how shadows are cast on real fabric and then going through a bunch of trial and error.

- Once the position of the shadows has been decided you can figure out the shapes of the creases.

- On a different note, white ink was used to add patterns to the lace.

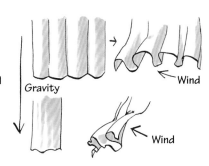

Gravity ← Wind

Wind

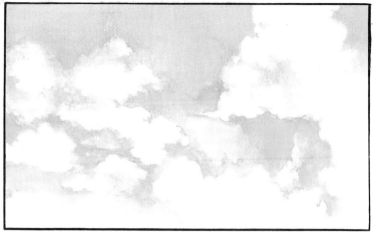

Spring Sky and Clouds

G000 Pale Green	Color of the lighter shadows
B01 Mint Blue	Base color for the shadows on the clouds
B12 Ice Blue	Base color of the sky
B91 Pale Grayish Blue	Used for darker shadows
0 Colorless Blender	Used to blend colors

- When you paint the sky the important part is the shape of the clouds. Pay close attention as cloud shapes are different in each season.

- Next, decide on your background color. The color of the sky darkens from the ground up to the sky. Making this gradual color change more apparent brings out a summer-like sky.

- Decide on the colors and gradation and then apply the base color of the sky. After blending the base color around the cloud, apply shadows.

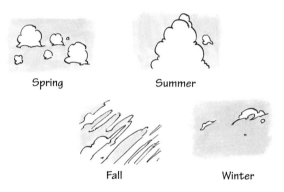

Spring Summer

Fall Winter

Different Textures on Cogs

Different textures can be rendered on identical shapes depending on the method one chooses. This example uses cogs. Metal and wood are naturally associated with the cog, but you can create different cog tones, such as stone, ice, leather, etc., depending on the coloring method.

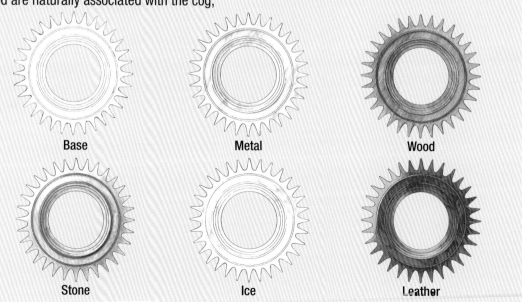

Base Metal Wood

Stone Ice Leather

Scene 1: Contract with the Devil 52

Scene 2: Dragon 88

Scene 3: Caterpillar Fungus 116

Scene 4: Dancer 138

Drawing Steps

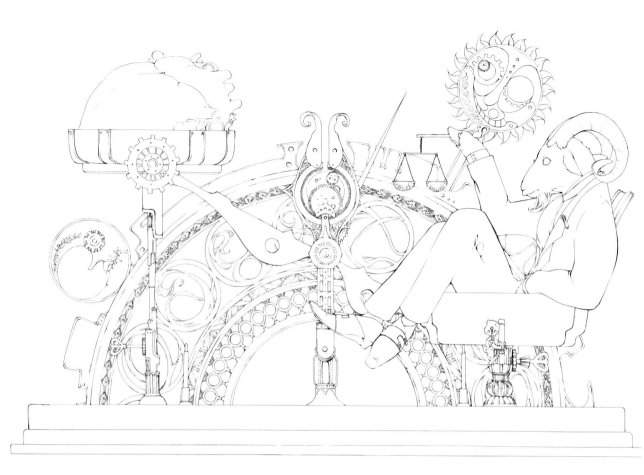

Scene 1
Deal

Contract with the Devil

This image is based on the idea of surrendering one's soul by signing a contract with the devil. In some mysterious place the devil and someone's heart are sitting on a scale. The scale itself emanates an enigmatic atmosphere by projecting both the day and night sky. This section focuses on rendering textures like metal, sky, horn, and the fur of a goat.

▌Rough Sketch

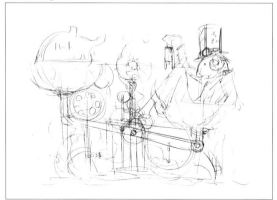

To create the most useful texture rendering example we will use an animal with fur and a mechanical object. The hands of the goat are similar to those of a human.

▌Outline

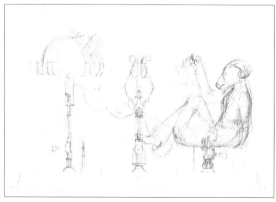

I prefer to draw machines that actually work. In order to grasp its structure firmly I outlined the mechanism of the scale with fine lines while considering its function.

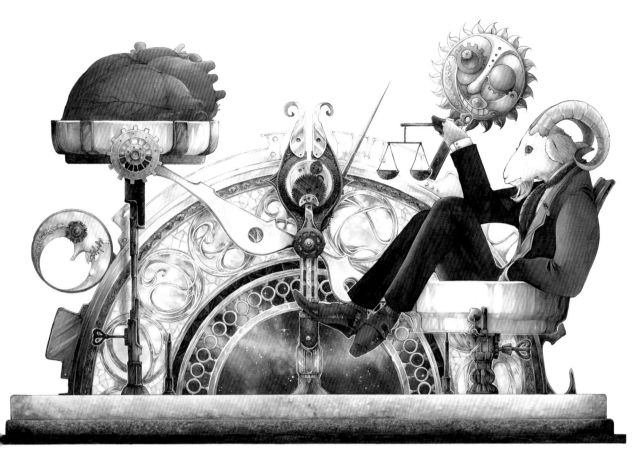

Illustration Points

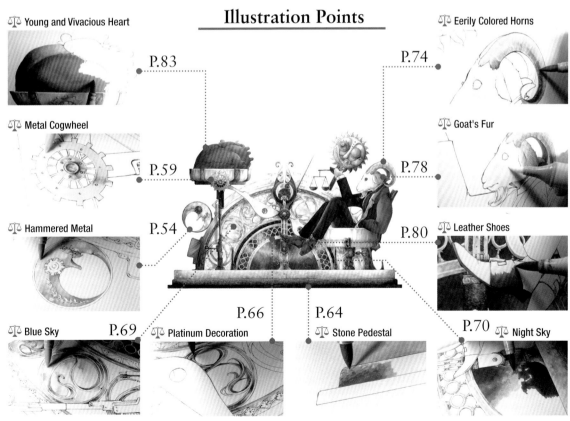

⚖ Young and Vivacious Heart

P.83

⚖ Metal Cogwheel

P.59

⚖ Hammered Metal

P.54

⚖ Blue Sky

P.69

⚖ Platinum Decoration

P.66

⚖ Stone Pedestal

P.64

⚖ Erily Colored Horns

P.74

⚖ Goat's Fur

P.78

⚖ Leather Shoes

P.80

⚖ Night Sky

P.70

Planning Light and Shadow

Light Source

Shadow on the heart

Shadows on the scale

Shadows on the devil's clothes

⚖️ Hammered Metal

This is a decoration made from hammered silver. The light source, and surrounding objects, are reflected on the surface.

Here!

Before

After

⬚ Undercoloring

W4 Warm Gray No.4 — Begin by coloring the tip of the shaded area.

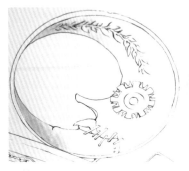

W1 Warm Gray No.1 — Apply the base color (W1) while blending.

0 Colorless Blender — Apply #0 to blend W4 into W1.

W4 Warm Gray No.4 — Add shadows to the uneven spots.

W1 Warm Gray No.1 — Blend the base color (W4) over the shadows.

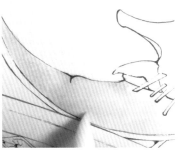

0 Colorless Blender — Blend everything with #0.

☐ Add Shadows to Create a Three-dimensional Feel

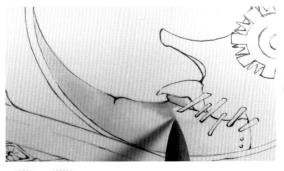

 Add emphasis to the indented areas.

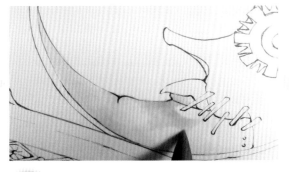

Blend the base color (W1) over the indented areas.

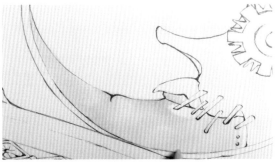

 Blend everything with #0.

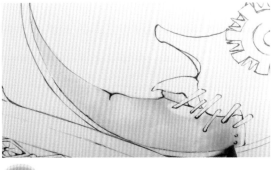

Add shadows to emphasize the curves of the crescent.

☐ Creating the Distinct Nose

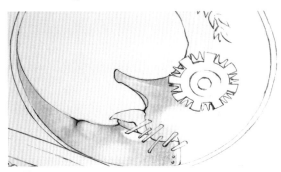

Apply W4 for the darkest shadows, then create the overall shape of the nose.

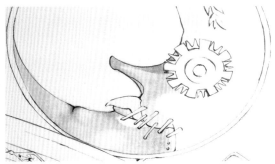

Add subtle redness to the reflection of the metal shaft on the scale.

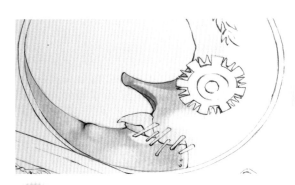

Similarly, add a red (Y91) shadow on the opposite side.

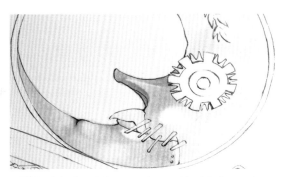

Color the whole crescent as you blend the base color (W1) on the nose.

⬚ Color Around the Face

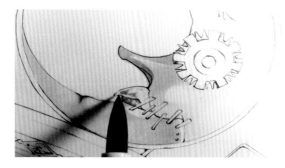

BV20 *Dull Lavender* — Let's draw the distinctive shape around the mouth. Add dark shadows in the shape of a warped "I."

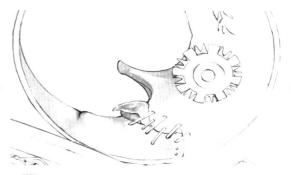

W1 *Warm Gray No.1* — Blend the base color (W1) to adjust the shadows.

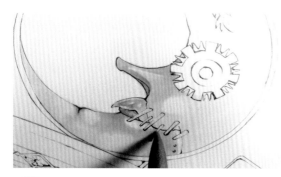

BV20 *Dull Lavender* — Add further shadows to the stitches and dent of the chin.

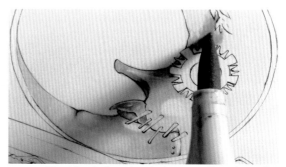

V01 *Heath* — Blend the shadows. In order to express the redness of the silver just add something from the V-color family (V01).

⬚ Improving the Details on the Inside Edge of the Crescent

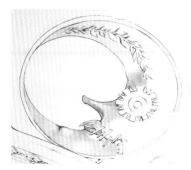

BV20 *Dull Lavender* — Add shadows inside the upper relief.

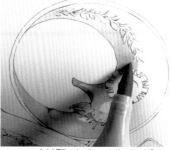

T2 *Toner Gray No.2* — Add T2, starting at the top. Go down to the upper relief to create a gradation.

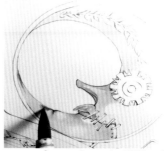

BV20 *Dull Lavender* — Once again, overlay BV20 on the shadows around the mouth. Add intense shadows to the edges.

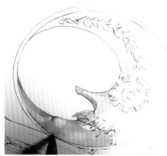

T2 *Toner Gray No.2* — Darken the shadows while blending and softening to create a hammered surface.

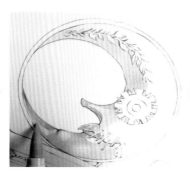

W1 *Warm Gray No.1* — Soften the edges to blend.

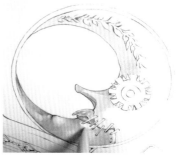

V01 *Heath* — Blend V01 mainly around the edges of the highlights.

☐ Casting Shadows on the Relief

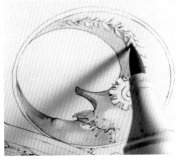

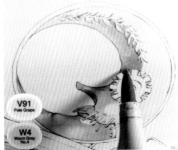

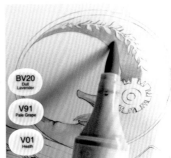

V95
Light Grape

Add a red-ish color (V95) to the leaf shadows in the relief.

After blending V91 on the shadows, drop W4 above the eye to deepen the shadows.

After applying BV20 from the top of the relief, blend with V91. Then, shade with V01.

☐ Color the Outside Edge of the Relief

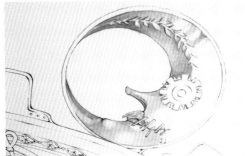

T2
Toner Gray No.2

Begin to color the outside edge of the relief. Keep in mind that you need to draw as if you were creating the shape of an "I."

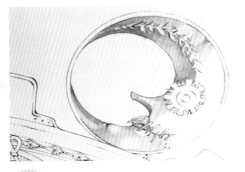

W1
Warm Gray No.1

Apply W1 to soften the edges of T2.

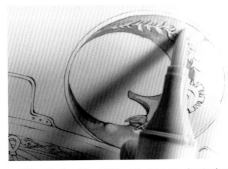

V01
Heath

Further, blend V01 while thinking about where light is cast.

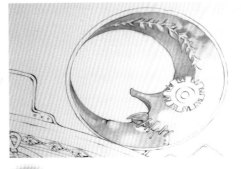

V20
Wisteria

Add shadows to create an uneven surface.

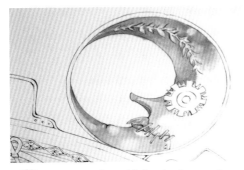

T2
Toner Gray No.2

Soften the edges while keeping the overall unevenness of the surface in mind.

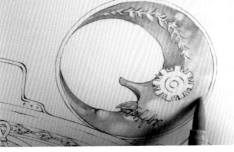

V01
Heath

W1
Warm Gray No.1

After blending V01 along the edge of the crescent, apply W1 to the back of the crescent.

Finishing

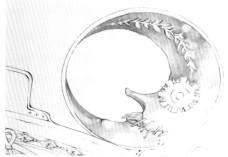

W4 Warm Gray No.4 **T2** Toner Gray No.2 After applying W4 to add shadows to the relief, apply T2 around the eye to add shadows there as well.

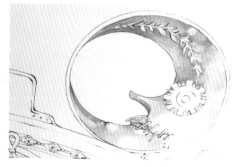

W1 Warm Gray No.1 Soften the shadows with W1.

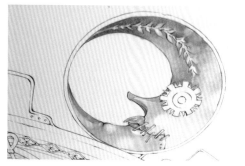

T2 Toner Gray No.2 Add darkness to the shadows cast on the outer edge of the crescent.

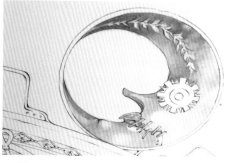

T2 Toner Gray No.2 **BV20** Dull Lavender Apply T2 and BV20 repeatedly along outside edge of the crescent to deepen the color.

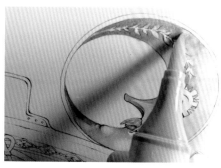

V01 Heath Also, add deepness along inside edge. But, it should be less deep than the outside edge.

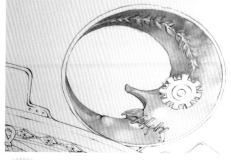

V95 Light Grape **V91** Pale Grape Apply V95 along inside edge, soften edges of V95 with V91.

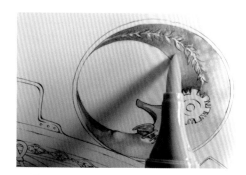

V01 Heath Adjust the details.

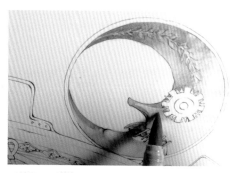

T2 Toner Gray No.2 **W1** Warm Gray No.1 Apply T2 and then soften edges of T2 with W1. Repeat this until achieving satisfactory results.

⚖ Metal Cogwheel

Be careful! Shiny metal reflects surrounding objects.

⬚ Color the Center of the Cogwheel

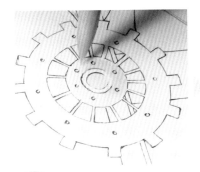

YG21 *Anise* First, color only the inside of the bearing.

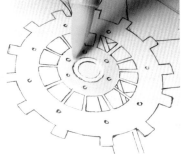

YG91 *Putty* Add a light underlay (YG91) on the disk around the bearing.

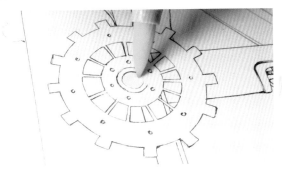

Y19 *Napoli Yellow* Overlay Y19 where Y91 was applied in the previous step.

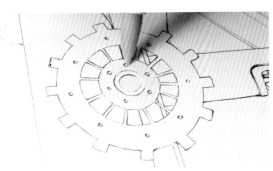

YG21 *Anise* Add another layer (YG21) wherever you will color next and to add highlights.

N3 *Neutral Gray No.3* Lightly add shadows.

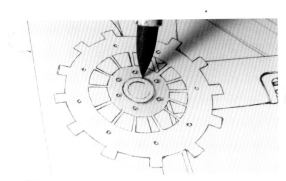

Y28 *Lionet Gold* Add distinctive shadows (Y28) around the bearing and rivets.

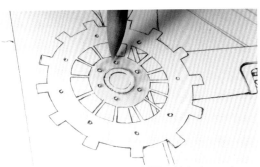

N3 *Neutral Gray No.3* While softening the edges of Y28, add shadows using N3. Outline the shape of the "I" when adding the shadows.

Basics for Adding Shadows

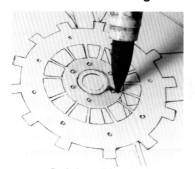

N6 Neutral Gray No.6
Begin by applying strong metallic shadows (N6). Leave out the outside edge.

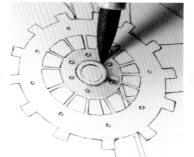

Y28 Lionet Gold
Apply Y28 as you soften the edges of the shadows that were applied in the previous step using N6.

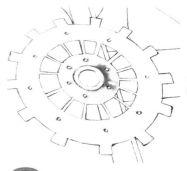

Y28 Lionet Gold
It should look like this.

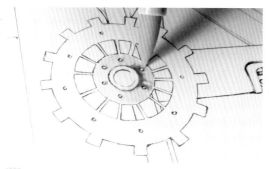

YG91 Putty
Soften the edge of the shadows.

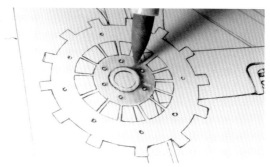

N3 Neutral Gray No.3
Continuously add pale shadows (N3).

Add Reflections from the Surrounding Objects

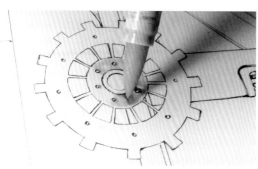

Y19 Napoli Yellow
Apply yellow (Y19) as if lifting the color of the shadows.

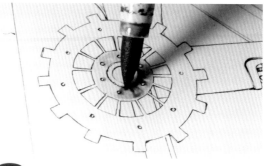

N6 Neutral Gray No.6
Add a strong shadow color (N6) in the shape of an "I."

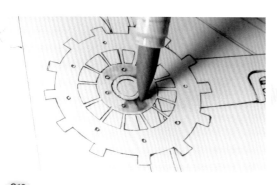

G12 Sea Green
Apply green (G12) to fill the "inside" of the "I."

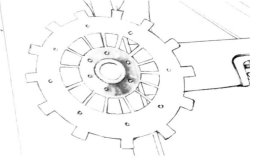

N6 Neutral Gray No.6
After shadows (N6) are added, it should look like the photo above. The outer edge is left unpainted so that the surface looks flat after adding shadows.

▯ Emphasize Metal-like Textures

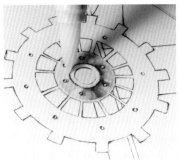

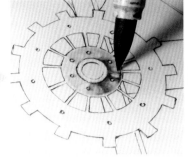

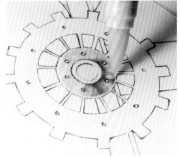

Y04
Acacia
Apply a metal color (Y04) to the highlighted area.

N6
Neutral Gray No.6
Drop N6 on the darkest shadows.

Y19
Napoli Yellow
Overlay a strong orange color (Y19) in order to bring out the realistic metal texture.

▯ Emphasize Texture

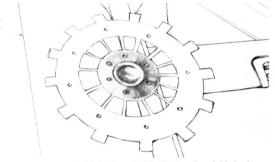

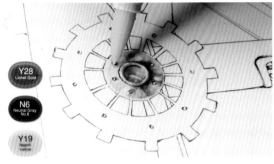

N6
Neutral Gray No.6

N4
Neutral Gray No.4
Add shadows inside the bearing. Add shadows by applying N6 and then add N4 to soften the edges of the shadows.

Y28
Lionet Gold

N6
Neutral Gray No.6

Y19
Napoli Yellow

YG21
Anise
After improving the details by applying Y28, N6, Y19, etc., add YG21 to the bright area.

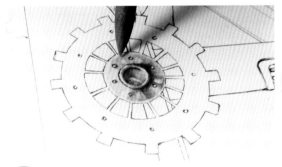

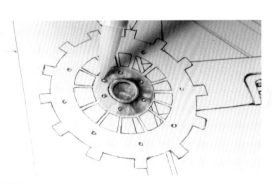

Y28
Lionet Gold
Overlay Y28 on the shaded areas.

Y04
Acacia
Add yellow (Y04) where light strikes strongly.

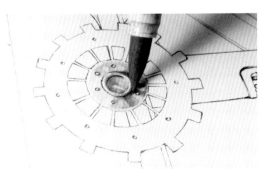

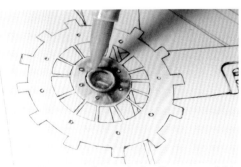

Y28
Lionet Gold
Apply Y28 to the shaded areas once again to add character.

Y19
Napoli Yellow
Apply Y19 to areas that receive less than average light in order to create "shades" of yellow. The inside disk is complete.

⬜ Color the Foundation of the Cogwheel

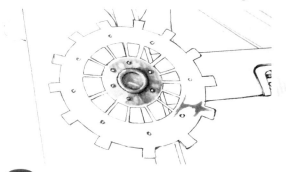

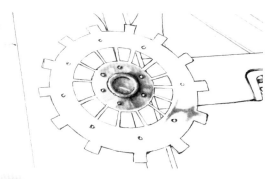

 N6 Neutral Gray No.6 — Paint a basic shadow (N6) on the cogwheel as if outlining a slightly warped "I."

Y04 Acacia — Softly overlay yellow (Y04).

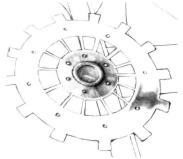

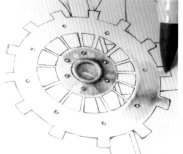

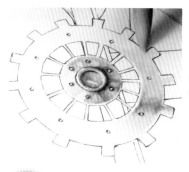

 N6 Neutral Gray No.6 — Over the yellow, add a shadow (N6) and smooth out its edges.

N4 Neutral Gray No.4 — Apply N4 thinly. Leave out the portion where we will add highlights later.

N3 Neutral Gray No.3 — Apply N3 more thinly than N4.

⬜ Adding the Metal Color

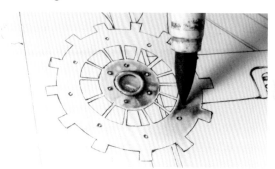

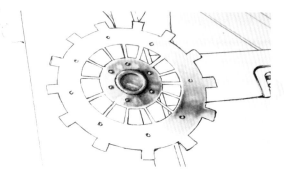

 N6 Neutral Gray No.6 — Repeat the steps in the previous section in a similar manner and finish adding details.

So far it looks like this.

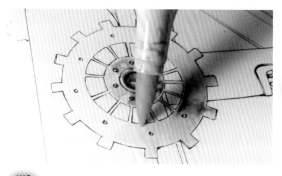

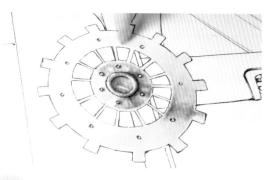

 Y19 Napoli Yellow — Next, begin to apply the base color of metal (Y19).

Y04 Acacia — Overlay Y04 on any bright areas.

⬚ Overlay Colors on the Metal Part

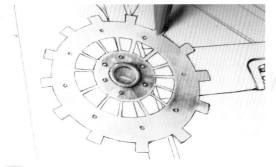

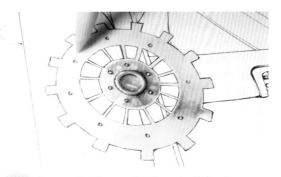

 Y19 Napoli Yellow — While keeping the overall form in mind, overlay a dark color like Y19.

Y04 Acacia — As you adjust the overall look, overlay Y04 on the areas facing the light.

⬚ Finishing Up while Considering Ambient Light

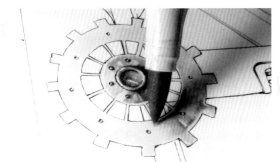

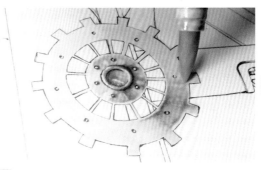

 Y28 Lionet Gold **N6** Neutral Gray No.6 **N4** Neutral Gray No.4 — Apply Y28 to the darkest shadows, and then soften the edges of those shadows using N6 and N4.

Y19 Napoli Yellow — Apply Y19 along the border between the darkest shadow and the metal.

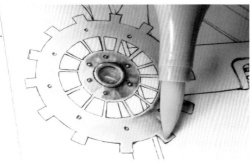

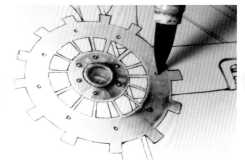

YG21 Anise — Apply green (YG21) while remaining cognizant of the blue ambient light.

 N6 Neutral Gray No.6 — Add N6 to deepen the shadows around the rivets.

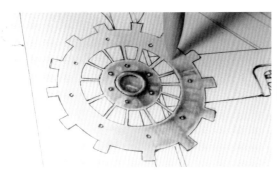

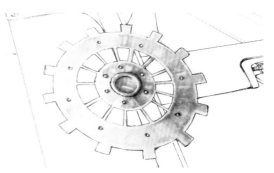

 Y28 Lionet Gold **N6** Neutral Gray No.6 **N4** Neutral Gray No.4 — Repeat the steps above in order to finish adding details.

Add shadows to everything using N-family markers. And then, finish gradations of green and yellow.

⚖️ Stone Pedestal

This is the stone pedestal that supports the scale. Apply colors intently in a dot pattern.

⬚ Rough Surfaced Stone

W6
Warm Gray No.6
Apply W6 in dots by pressing down the tip of the brush.

C4
Cool Gray No.4
Let the paint dry for a short time and then overlay C4 in a similar dotting manner. Then blend. Be sure to leave out highlighted areas.

YG95
Pale Olive
Further, overlay YG95 in a similar dotting manner.

BV20
Dull Lavender
Do the same with BV20.

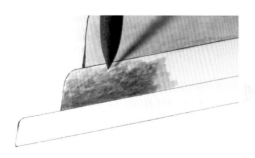

YG91
Putty
And, do the same with YG91.

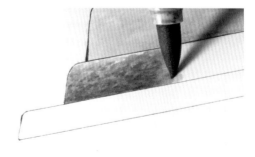

BV20
Dull Lavender
Repeat the steps above. Paint dots with a dark color, and then let dry for a short time. Then, overlay other colors and blend. In this manner, an uneven rough surface texture can be successfully rendered.

⬚ Glossy Black Stone

T10 Toner Gray No.10 — Paint shadows on the uneven surface. Hold the point of the marker so that it faces straight down. Make these dots by lightly sliding the brush sideways.

W8 Warm Gray No.8 **W7** Warm Gray No.7 — Overlay W8 and W7 to blend in with T10.

 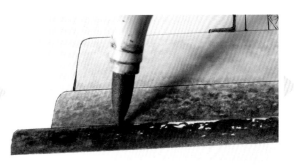

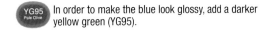

B26 Cobalt Blue — Blend in B26 to create reflections on the stone.

YG95 Pale Olive — In order to make the blue look glossy, add a darker yellow green (YG95).

W8 Warm Gray No.8 — Adjust the overall look with W8 to complete.

⚖️ Platinum Decoration

These are the decorations on the scale. They are made of platinum and look somewhat like ancient numbers.

Here! Before After

📖 Begin Your Coloring with the Details

B23 *Prehalo Blue* First, start with a dark shadow.

BV20 *Dull Lavender* Add a pale shadow (BV20) over the dark shadow to blend.

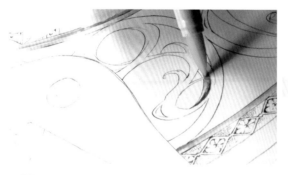

BG000 *Pale Aqua* Soften the edges of the shadow with BG000.

BG000 *Pale Aqua* Apply BG000 on the border between light and shadow.

T2 *Toner Gray No.2* Overlay gray (T2) to bring out a three-dimensional feel.

⬚ Add Shadows to the Details

BV23
Grayish
Lavender
Add shadows (BV23) thinly using the very tip of your marker.

BV20
Dull
Lavender
Overlay BV20 to blend.

BG000
Pale Aqua
Further, overlay BG000.

T2
Toner Gray
No.2
Add gray (T2) along the border of the bright surface.

⬚ Finishing up

BV23
Grayish
Lavender
Precisely add BV23 to the shadow.

BV20
Dull
Lavender
Since the details are done, move on to add shadows to the larger area.

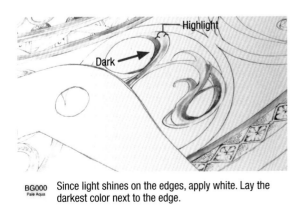

BG000
Pale Aqua
Since light shines on the edges, apply white. Lay the darkest color next to the edge.

☐ Color the Circumference

BV23
Grayish
Lavender

Apply the darkest color (BV23) to add shadows along the circumference.

BV20
Dull
Lavender

Apply BV20 to soften the edges of the darkest color.

T2
Toner Gray
No.2

T1
Toner Gray
No.1

Apply T2 and T1 to further soften the edges of the darkest color.

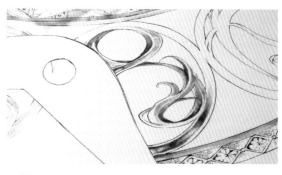

BG000
Pale Aqua

Apply BG000 over the darkest color and extend.

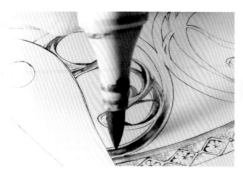

BG93
Green Gray

Add shadows (BG93) that distinguish parts of the scale and the decoration.

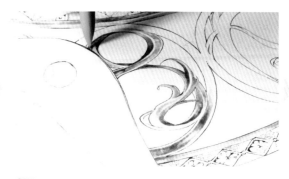

G000
Pale Green

Overlay G000 specifically on the shadows.

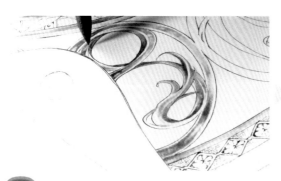

BV23
Grayish
Lavender

Apply BV23 to adjust the shadows.

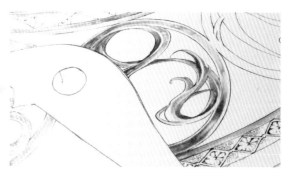

Complete.

⚖️ The Blue Sky

Behind the platinum decoration is some blue sky. Color the clouds so that they blend in with the decoration.

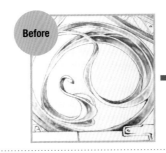

Before

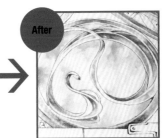

After

▢ Color the Clouds by First Casting Their Shadows

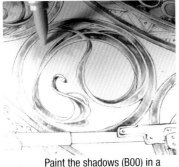

B00
Frost
Blue

Paint the shadows (B00) in a manner that outlines the shape of the clouds.

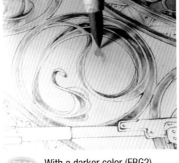

FBG2
Fluorescent
Dull B.G.

With a darker color (FBG2), create a shadow.

B00
Frost
Blue

Apply B00 to soften the edge of the shadow.

FBG2
Fluorescent
Dull B.G.

B00
Frost
Blue

Do the same to add more cloud shadows.

0
Colorless
Blender

Softening edges of the shadows.

G000
Pale Green

Add green (G000) to bring about a certain brightness.

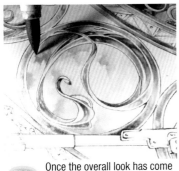

FBG2
Fluorescent
Dull B.G.

Once the overall look has come together, add FBG2 to the shadows.

FBG2
Fluorescent
Dull B.G.

Further overlay FBG2.

B00
Frost
Blue

Soften the edges of the shadows to complete.

⚖️ Night sky

Under the weighing dish, behind the platinum decoration, is the night sky. This part is colored like a dot painting.

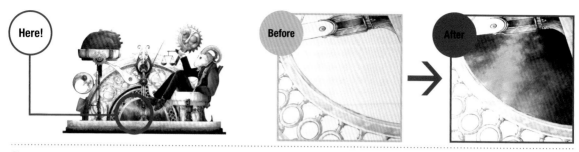

☐ Basic Coloring Method

B000
Pale Porcelain Blue
Undercoloring. Decide on where to make things bright or dark.

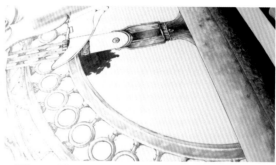

B99
Agate

B95
Light Grayish Cobalt
Begin painting with a darker color. B99 is closest to the edge. Spread that with B95.

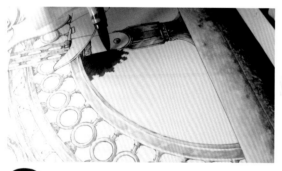

B39
Prussian Blue
Apply a lighter color (B39) and spread.

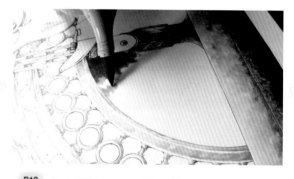

B12
Ice Blue
Apply B12 by purposefully making uneven brush strokes.

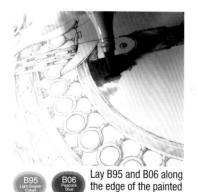

B95
Light Grayish Cobalt

B06
Peacock Blue
Lay B95 and B06 along the edge of the painted area.

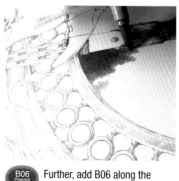

B06
Peacock Blue
Further, add B06 along the edge.

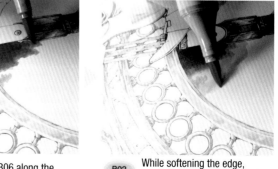

B02
Robin's Egg Blue
While softening the edge, spread B02 out from the darker colors.

▢ Color Over the Base

B95 Light Grayish Cobalt — Apply B95 to create darker areas, similar to making the shadow of the cloud.

B39 Prussian Blue — Finely color the shadows of the clouds and the stars.

B06 Peacock Blue — As you color, soften the edges and overlay another color. It is not necessary to make neat gradations. Rather, leave some unevenness that looks like an actual object.

B39 Prussian Blue — Blend in B39 like you are dot painting.

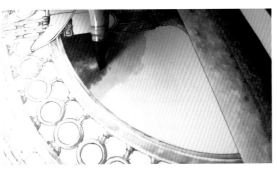

B12 Ice Blue — Similarly, add some dark areas.

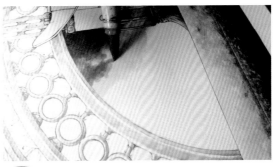

B06 Peacock Blue — Spread B06 further with the intent of making the shape of a cloud.

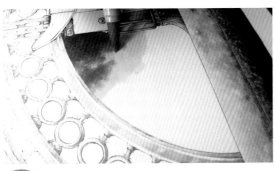

B06 Peacock Blue — Blend some B06, in a dot painting manner, in the dark areas you initially painted.

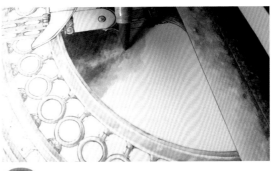

B06 Peacock Blue — Link your dots together in a single line.

☐ Move on to a New Space

B02
Robin's Egg Blue
Apply B02 in order to soften the edge of the already colored area.

B99
Agate
B95
Light Grayish Cobalt
Start to paint in the blank space by following the steps from the previous section.

B39
Prussian Blue
Now, let's paint cloud-like shapes.

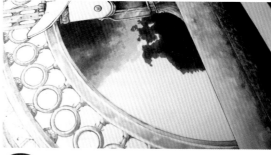

B99
Agate
If you find that the depth of color is lacking, drop in some B99 and let it bleed.

B39
Prussian Blue
Soften the edge in a dot painting manner. Vibrant colors work best here.

☐ Neatly Connecting Painted Areas

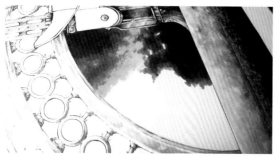

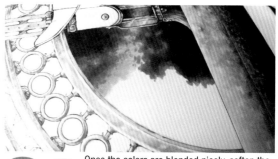

Dot paint in the same manner as for the darker shadow and start to fill in the blank area.

B06
Peacock Blue
B12
Ice Blue
Once the colors are blended nicely, soften the edges using a color one level brighter (i.e., B06 and B12).

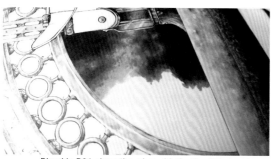

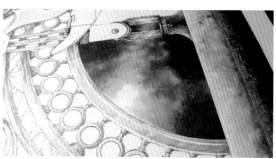

B01
Mint Blue
Blend in B01 along the edge with the tip of the brush, lightly pushing against the surface of the paper as if dot painting.

B02
Robin's Egg Blue
In a similar manner, blend in B02 and then the blank area will be filled. A successful attempt should look like the example above. Try to create a "stain" with unevenness.

Adding More Darkness

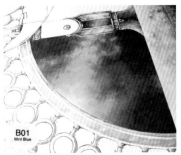

B01
Mint Blue

Keep applying color in a dot painting manner to create gradations. Careful! Be sure to exclude areas where light is cast.

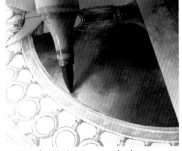

B39
Prussian Blue

I added one more shadow because I felt that my attempt came out a little too bright.

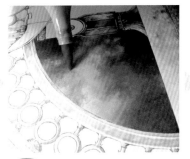

B06
Peacock Blue

Overlay B06 as in the previous step.

B02
Robin's Egg Blue

Let it dry a little and then blend in B02.

B01
Mint Blue

Further blend with a pale color, something like B01.

B00
Frost Blue

Apply B00, which is one level lighter than the color applied above, to complete.

Adjust the Overall Shading to Complete

0
Colorless Blender

Add highlights to emphasize the color of the sky. Apply #0 in a line drawing motion and then in a dot painting motion where you think it is necessary.

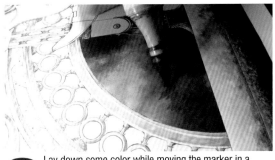

B39
Prussian Blue

Lay down some color while moving the marker in a zigzag. Overlay the color to the point where the alcohol floats on the surface. This will create a certain dullness.

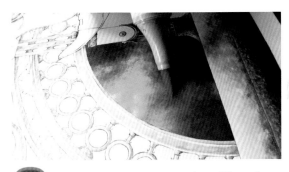

B06
Peacock Blue

Similarly, apply B06 in a zigzag to clean off the surface.

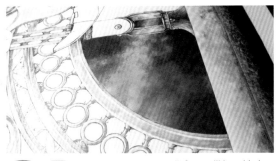

B06
Peacock Blue

B02
Robin's Egg Blue

Make the lower part dull. Stars will be added later using white ink.

⚖ Eerily Colored Horns

Paint the devil goat's horns. Paint finely.

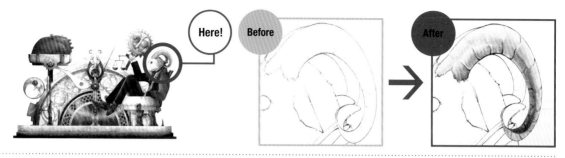

▢ Undercoloring

YR31
Light Reddish Yellow

Apply a base color (YR31), while excluding highlights and shadows.

YR31
Light Reddish Yellow

Overlay YR31 repeatedly to adjust the depth of the color.

YG21
Anise

Add YG21 to the highlights. In order to express a certain eeriness, add some green.

YR31
Light Reddish Yellow

Overlay your base color (YR31) and soften the green.

BG11
Moon White

Overlay BG11 to adjust the shading.

YR31
Light Reddish Yellow

Again, apply the base color (YR31) to adjust.

☐ Add Shadows While Considering the Shape of the Horns

 Add shadows along the shape of the horn. Be sure to move the marker upward. If the brush stroke is not uniform, texture will be lost.

 After reapplying YR24, overlay YR31 to soften the edge of the YR24. Maintain the upward brush stroke.

 Apply YG03 to blend in the BG11 applied previously.

YR31
Light Reddish Yellow — Adjust colors with YR31.

☐ Add a Dark Shadow to Create Prominence

 Drop in some N6 to add a dark shadow. Move the marker from outside to inside.

BV31
Pale Lavender — Apply BV31 to soften the edge of the dark shadow and spread the color.

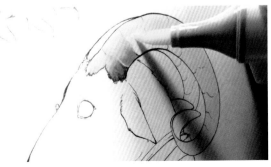

Y04
Acacia — Add light so as to emphasize the indentation that runs along the horn.

⬜ Highlight the Indentation That Runs Along the Horn

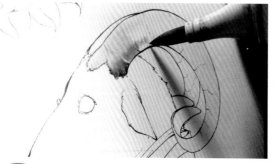

 Y28 Lionel Gold
Apply Y28 to add slightly pale shadows.

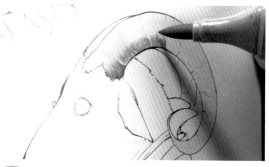

YG93 Grayish Yellow
Blend in YG93 over those pale shadows.

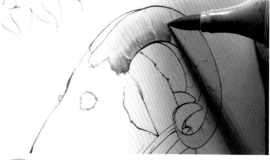

 YG93 Grayish Yellow
Apply YG93 to bring out the indentation.

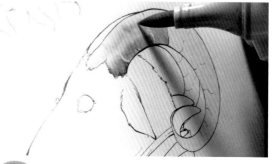

YG93 Grayish Yellow
Apply YG93 to add shadows.

⬜ Create Shadows Along the Curve

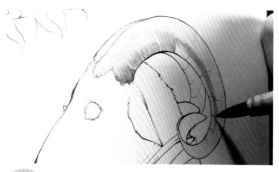

YR23 Yellow Ochre
Apply YR23 to paint the shadow along the curve in one go.

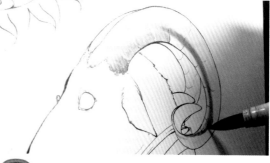

Y28 Lionel Gold
Similarly, apply Y28 to paint the darker shadow.

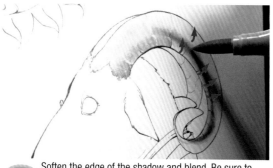

Y26 Mustard
Soften the edge of the shadow and blend. Be sure to move the marker in one direction while thinking about the roundness of the horn.

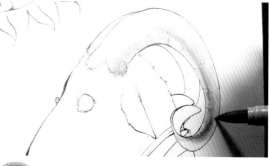

Y26 Mustard
Do the same for the lower part.

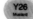

⬚ Finish the Details

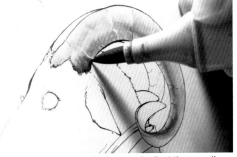

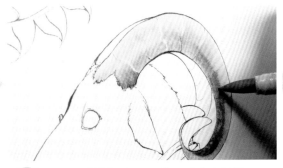

YR23 Yellow Ochre — Draw growth lines on the horn and adjust the overall look. Then overlay YR23, beginning from the shadow, and deepen the color.

BV34 Bluebell — Add blue (BV34) to increase the eerie feel. Add it horizontally.

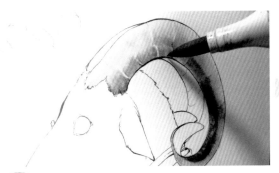

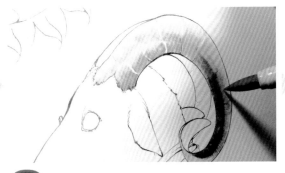

YR23 Yellow Ochre — Apply YR23 to the edge of the horn.

BV34 Bluebell — In the same manner, apply BV34.

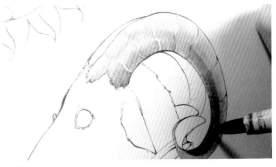

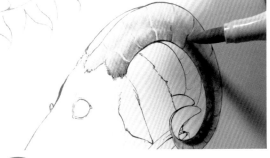

 BV34 Bluebell — Apply BV34 where the shadow is the deepest.

BV34 Bluebell — Overlay BV34.

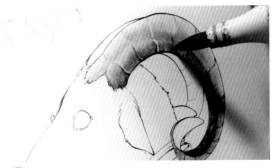

 N6 Neutral Gray No.6 — Apply N6 to paint deeper shadows to complete.

⚖️ Goat's Fur

Color the goat-headed devil. Be persistent when attempting to correctly render fur texture.

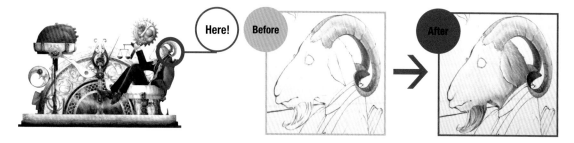

Color Fur at the Back of the Head

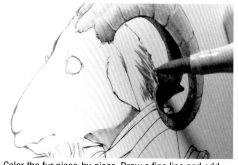

BV34 Bluebell — Color the fur piece-by-piece. Draw a fine line and add some thickness. Create a layer of finely drawn lines. Begin with the shaded area.

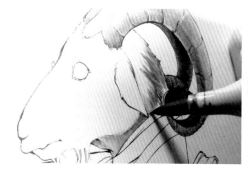

BV20 Dull Lavender — Add shadows using a slightly lighter color (BV20).

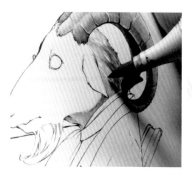

BV20 Dull Lavender — Color the lightly shaded area in the same manner.

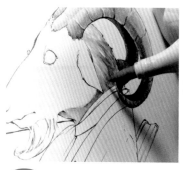

BV34 Bluebell — Add darker shadows and adjust.

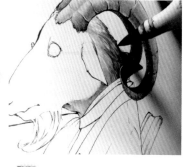

BV20 Dull Lavender — Further overlay BV20.

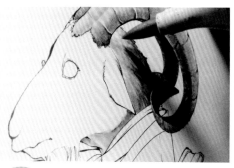

YG93 Grayish Yellow **Y26** Mustard — Paint the base color on the fur and the shadows.

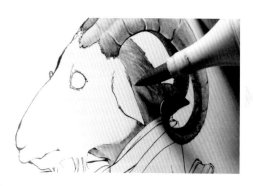

BV20 Dull Lavender — Adjust the shadows and finish for now.

⬚ Color the Facial Fur

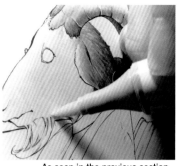

Y21 Buttercup Yellow — As seen in the previous section, paint fur one hair at a time. The key point here is to make the hair short.

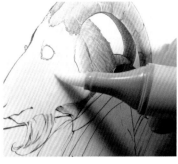

0 Colorless Blender — Soften the lines so they are not so prominent.

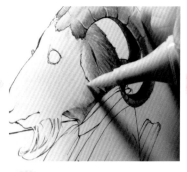

Y21 Buttercup Yellow — Add more fur.

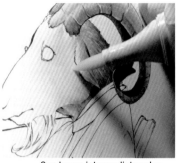

G000 Pale Green — Overlay an intermediate color and blend in with the shaded area.

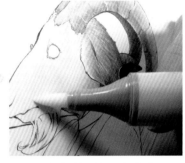

0 Colorless Blender — Again, blend in and adjust overall shades.

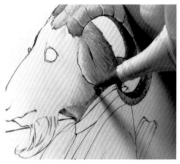

BV34 Bluebell — Lay a darker shadow color (BV34).

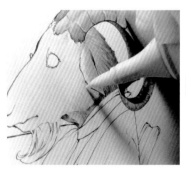

Y21 Buttercup Yellow — Add streaks of fur.

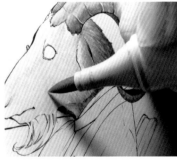

N1 Neutral Gray No.1 — Add lines on the curved areas to create shadows.

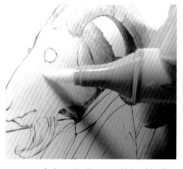

0 Colorless Blender — Soften the lines and blend in the colors.

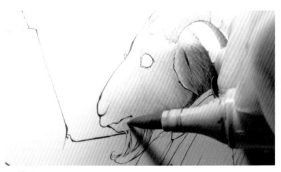

E31 Brick Beige — Cast shadows around the mouth.

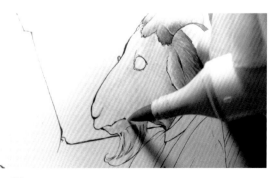

N1 Neutral Gray No.1 — Adjust overall shading to complete.

⚖️ Leather Shoes

These are finely polished, glossy, leather shoes. The key point is to incorporate the reflections of surrounding objects.

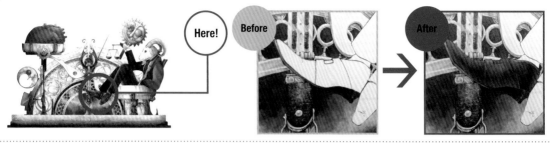

▯ Coloring the Instep

E09 Burnt Sienna — Move the marker vertically from the sole and apply E09 by drawing lines.

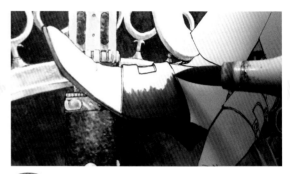

E08 Brown — Overlay E08 and fill blank space.

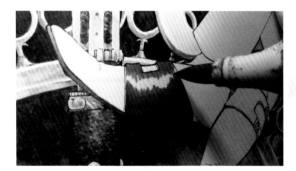

E07 Light Mahogany — Apply E07 to the instep in the same manner.

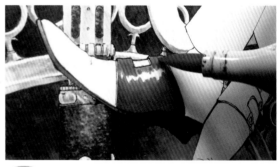

YR04 Chrome Orange — Overlay YR04 for reflections.

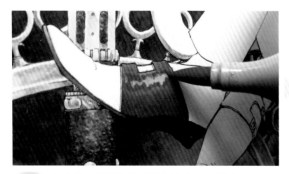

B02 Robin's Egg Blue — Apply blue (B02) to the highlighted area. This is a reflection of the night sky.

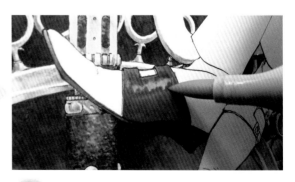

YG41 Pale Cobalt Green — Overlay YG41.

Adding Depth to the Details

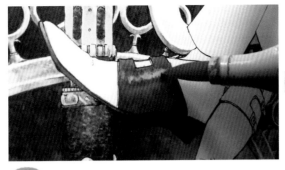

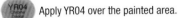 **YR04** Apply YR04 over the painted area.

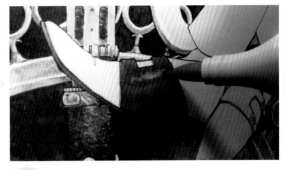 **B02** Again, apply blue (B02).

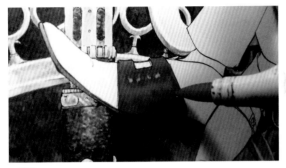 **E13** Apply E13 mainly on the highlighted area.

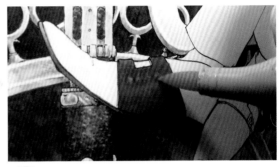 **E09** Draw a line vertically as you apply E09.

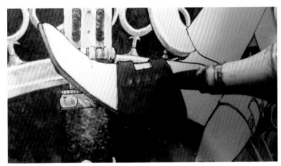 **E09** Apply repeatedly.

 E07 Apply E07 to soften the edges of the lines drawn with E09.

 E13 Further overlay E13.

 Y38 Blend in Y38 to adjust overall shading.

Finishing up

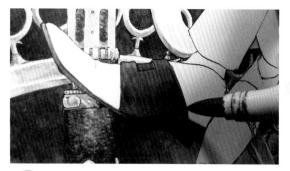

 Add shadows. Apply E74 by drawing lines.

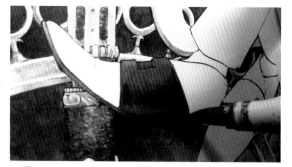

 Apply E09 as you soften the edges of the lines drawn with E74.

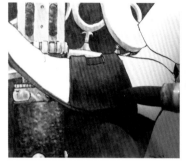

 Overlay E07.

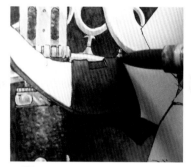

 Overlay E07 further and blend in.

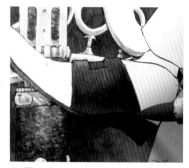

Apply YR04 to blend the overall shading.

Finish the Toe and the Heel

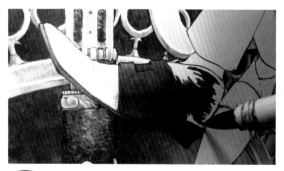

 Paint the heel of the shoes as above.

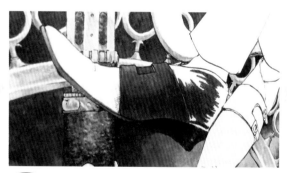

 Overlay E29 while making the center dark.

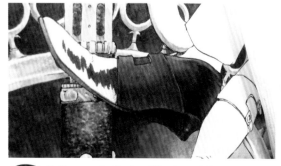

 Do the same for the toe of the shoes. Add shadows from the center.

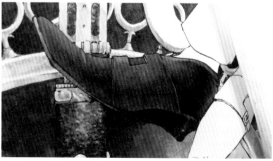

 Overlay colors to complete.

⚖️ A Young and Vivacious Heart

This is a fresh heart, recently removed from a body. That being said, we need to render half of the heart as dead due to the contract that was signed with the devil.

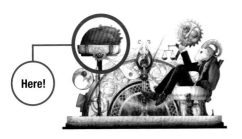

Before

After

▯ Paint Dead Portion's Base

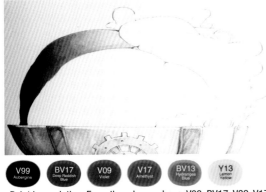

V99 Aubergine **BV17** Deep Reddish Blue **V09** Violet **V17** Amethyst **BV13** Hydrangea Blue **Y13** Lemon Yellow

Paint in gradation. From the edge we have: V99, BV17, V09, V17, BV13, Y13.

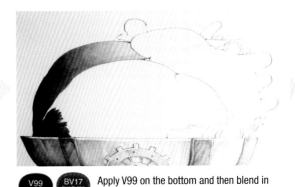

V99 Aubergine **BV17** Deep Reddish Blue Apply V99 on the bottom and then blend in BV17 along the edge of that V99.

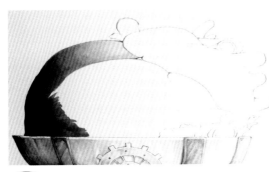

BV08 Blue Violet Apply BV08 in a fan shape.

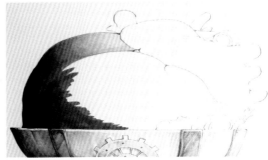

V09 Violet While taking into account the curve of the left ventricle, apply V09.

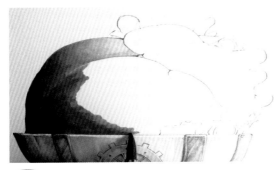

V15 Mallow Overlay V15 on the V09 and continue to color.

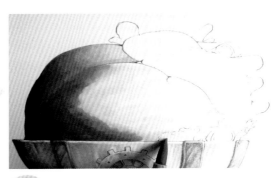

BV02 Prune Apply BV02 over the entire area of the left ventricle.

▢ Paint the Left Ventricle and the Left Atrium

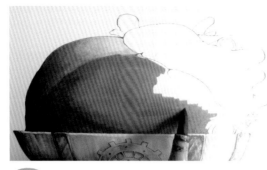

 R22 *Light Plavin* Apply R22 all the way up to the left atrium.

V15 *Mallow* Overlay V15, mainly along the border of BV02 and R22.

R12 *Light Tea Rose* Paint the left atrium.

YR15 *Pumpkin Yellow* Apply YR15 on the highlighted area of the left atrium.

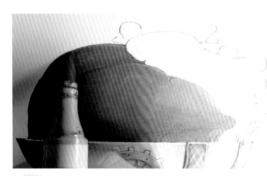

R12 *Light Tea Rose* Add redness to the right ventricle.

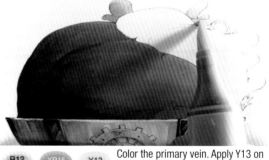

 R12 *Light Tea Rose* **YR15** *Pumpkin Yellow* **Y13** *Lemon Yellow* Color the primary vein. Apply Y13 on the brightest area and YR15 on the darkest.

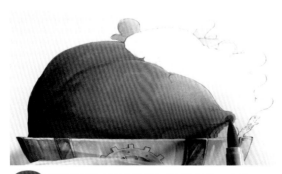

V09 *Violet* Paint the creases inside the vein. Since the vein is hollow you must make it round.

Color the Right Atrium

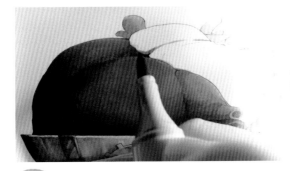

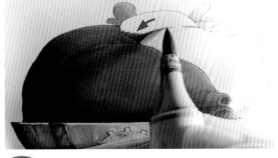

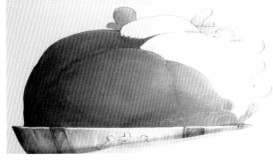

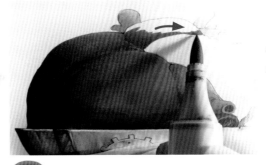

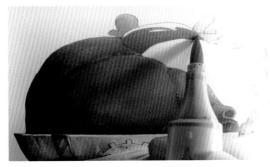

V04 Lilac — Outline the shadows of the right atrium.

E08 Brown — Move the brush downward toward the atrium.

E08 Brown — The shadow should look like this.

YR18 — Apply YR18 and extend the shadow.

 YR07 Cadmium Orange — Apply YR07 and extend the shadow to color the right atrium.

YR15 Pumpkin Yellow — Adjust the overall shading, except in highlighted areas.

Y13 Lemon Yellow — Add highlights to the right atrium and adjust the color of the vein.

 E08 Brown **YR18** **YR07** Cadmium Orange **YR15** Pumpkin Yellow

Color the primary vein. Create gradations at the base of the primary vein. Use markers ranging from E08 through YR18. Moving downwards, create gradation ranging from YR07 to YR15.

⬚ Color the Primary Vein

E08 Brown — As for the base of the main vein, apply E08 as if you were drawing lines.

E08 Brown — Stroke the brush in an arc along the curve.

YR07 Cadmium Orange — Apply YR07 from the edges of the ventricle and the atrium, thus creating a flow towards the center.

YR15 Pumpkin Yellow — Similarly, overlay YR15 while still thinking about the roundness of the heart.

Y13 Lemon Yellow — Overlay Y13 in the same manner.

Y13 Lemon Yellow — Overlay Y13 to add color.

⬚ Add Details to the Vein

BV13 Hydrangea Blue — Color the inside of the vein.

V17 Amethyst — Color the inside. Create a color that is the same as the dark part of the ventricle.

☐ Color Atrium Details

Y13 Lemon Yellow — After the colors on the left atrium have dried, apply Y13 to add luster.

BV13 Hydrangea Blue — Add fine shadows to render roundness.

YR18 Sanguine — Add the lines of the muscle.

☐ Color Veins to Finish

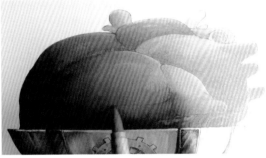

B29 Ultramarine — Color the veins on the heart using blue (B29).

B04 Tahitian Blue — After painting the dark part using B29, apply B04 thinly and extend the dark part.

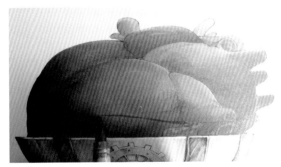
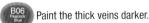
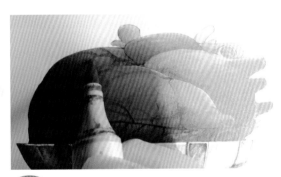

B06 Peacock Blue — Paint the thick veins darker.

V06 Lavender — Paint the veins further back using purple (V06).

YR15 Pumpkin Yellow — Add lines on the vein attached to the right atrium.

Y13 Lemon Yellow — Extend lines to complete.

Scene 2

At the cave

Dragon

A family of dragons is bathing. They usually live under the water, but their young live on land because they are weak. This section explains how to render textures like the sea, river, plants, and dragons.

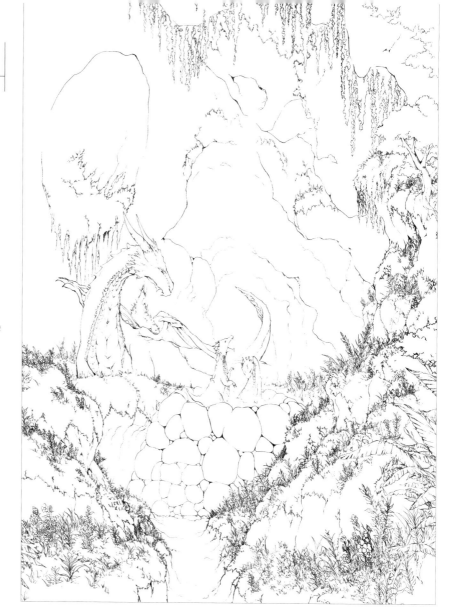

Illustration Points

🔥 **Meadow with Thin Grass**

🔥 **Dragon Scales**

P.112

P.98

P.102

🔥 **Cliffs with Reflections of Light**

🔥 **Clear Stream**

P.106

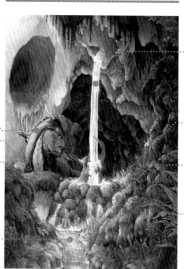

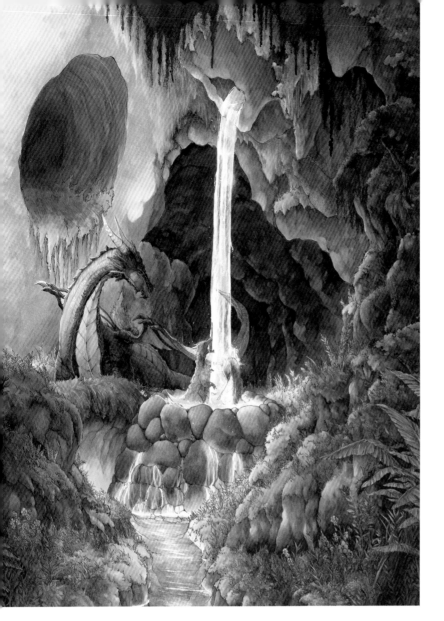

Rough Sketch

From the beginning of the rough sketch I had a pretty solid idea of what I would draw. The hole on the left is their den, not the entrance to a cave.

Outline

Roughly sketch out the general layout and the shape of the rocks. Plants, etc., are just outlined for now because the detailing is done during the coloring process.

🔥 Waterfall

P.90

🔥 Water Streaming Down the Stone Wall

P.100

P.94

🔥 Thickly Grown Fern Leaves

🔥 Bush Under the Cliff

P.92

Planning Light and Shadow

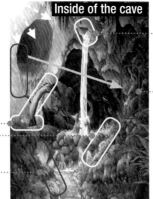

Light Source ↑ Outside of the cave

Inside of the cave

Where the light source shines

Reflections from the cliff on the opposite shore

Where the light shines

Reflections from the water

Waterfall

The key point is to color while thinking about the direction of the water flow.

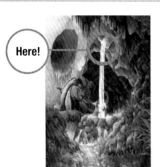

Here!

Before

After

Color the Base of the Waterfall

BG000
Pale Aqua — Undercolor the falling water.

B01
Mint Blue — Add a few water shadows.

BG000
Pale Aqua — Swipe your marker in the direction of the water falls.

0
Colorless Blender — Thoroughly add highlights and create gaps within the stream of the waterfall.

B01
Mint Blue

B02
Robin's Egg Blue — Repeat the steps above in order to add in-depth details. Think about the direction of the light, apply B000 to the shaded areas. Then, apply B01 or B02 over these areas.

☐ Detailing the Waterfall

YG00
Mimosa
Yellow

Since light is coming from the left, we must apply YG00 exclusively on the left side.

B0000
Pale
Celestine

Move your marker in the direction of the waterfall while blending with B0000.

N1
Neutral Gray
No.1

Add gray (N1) shadows to the top of the waterfall and the waterfall itself.

B000
Pale Porcelain
Blue

Soften the shadows, blend in B000.

N1
Neutral Gray
No.1

BV31
Pale
Lavender

Add shadows where the current of the waterfall is swiftest and then soften the shadows.

N1
Neutral Gray
No.1

Add fine shadows.

B000
Pale Porcelain
Blue

Prevent the shadows from becoming too dark. Always soften the edges using B000.

After repeatedly overlaying colors, the waterfall is complete.

Thickly Grown Fern Leaves

Color while focusing on the shapes of the leaves and the flow of veins on those leaves.

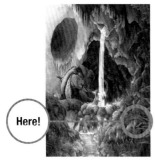

Here!

Before

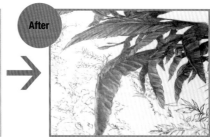

After

☐ Undercoloring

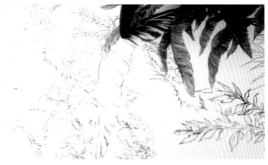

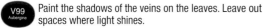

V99 Aubergine — Paint the shadows of the veins on the leaves. Leave out spaces where light shines.

G94 Grayish Olive — Overlay G94 on the shadows, including the spaces you left out previously. Leave the thick veins uncolored.

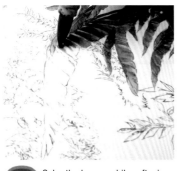

G94 Grayish Olive — Color the leaves while softening the shadows.

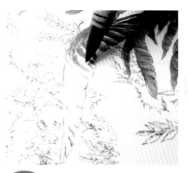

G94 Grayish Olive — Proceed to color the leaves in the same manner.

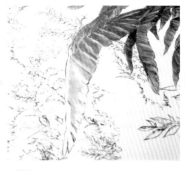

G12 Sea Green — Blend G12 over the colored area.

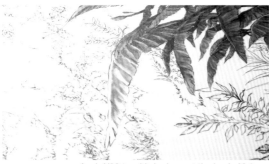

V99 Aubergine **G82** Spring Dim Green — Apply V99 to add shadows at the back. Make the shadows lighter as you move towards the tip of the leaf, and apply G82 instead of V99.

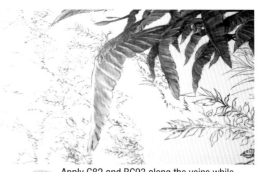

G82 Spring Dim Green **BG93** Green Gray — Apply G82 and BG93 along the veins while making gradations for shadows at the tip of the leaf.

⬚ Detailing the Leaf

BG93 Green Gray — Overlay BG93 to make the shadows deeper.

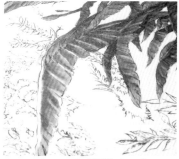

RV99 Argyle Purple — Lay purple (RV99) along the midrib and soften the color, all the while stretching it out thinly.

YG17 Grass Green — Make the midrib prominent.

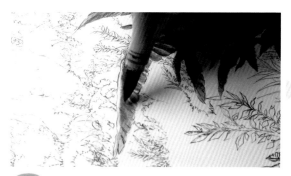

YG17 Grass Green — Trace the veins to make them stand out.

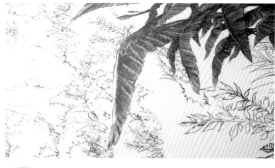

G82 Spring Dim Green — Apply G82 over everything and blend.

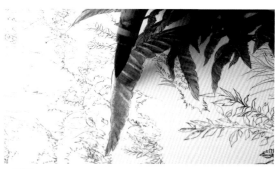

G94 Grayish Olive — Apply G94 in such a manner as to make the veins appear to float.

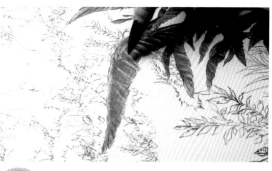

Y26 Mustard — Overlay Y26 in order to express light within the shadows.

G20 Wax White — Soften the tips of the leaves.

G94 Grayish Olive · **YG17** Grass Green — Soften the painted areas.

 # Bushes Under the Cliff

Move the marker in the direction the bush grows.

Here!

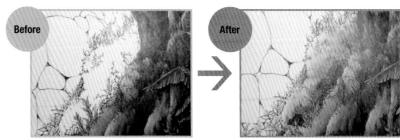

Before → After

▣ Undercoloring

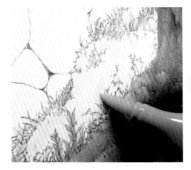

Y02
Canary
Yellow
Begin painting on the face that is hit by the light.

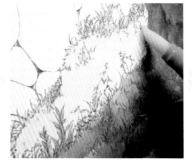

Y000
Pale Lemon
Soften the edge of Y02 with Y000 to create a gradation.

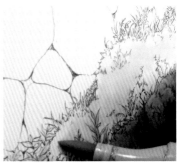

YG23
New Leaf
Overlay the color of the bush (YG23) while leaving out highlighted areas.

▣ Add Shadows

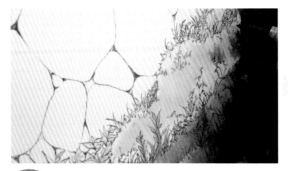

G94
Grayish
Olive
Add shadows to the uneven dirt surface.

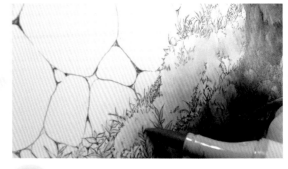

YG23
New Leaf
Overlay YG23 and blend in the shadows.

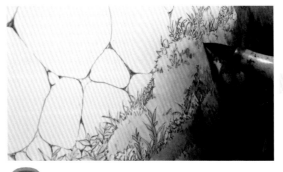

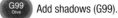
G99
Olive
Add shadows (G99).

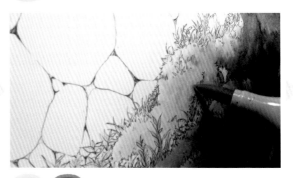

YG23
New Leaf
G99
Olive
Thoroughly overlay two colors (YG23, G99).

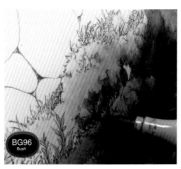

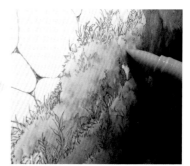

BG96 Bush — Add dark shadows at the root of the plants. Lightly push the tip of the nib against the paper and apply BG96 as you make dots.

YG23 New Leaf — Similarly, apply YG23 as you make more dots.

Y02 Canary Yellow — Add yellow (Y02) to the bright areas. Repeat the steps above to add more details.

Grouping the Bushes

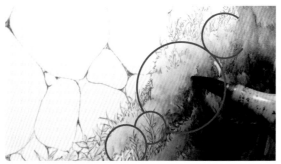

W7 Warm Gray No.7 — Overlay a dark color (W7) and then add shadows while remaining cognizant of each circled area (see picture).

W8 Warm Gray No.8 — Overlay W8 further to make the shadows deeper.

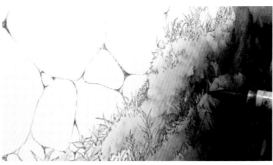

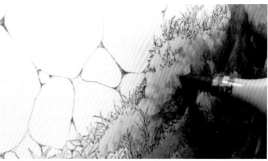

G99 Olive — Consider the shape of the plant and overlay G99 to make the tips of the plant sharp.

G99 Olive — Add shadows in the shape of the plant. It is somewhat troublesome, but it makes the plants appear much more realistic.

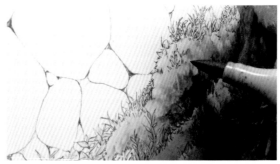

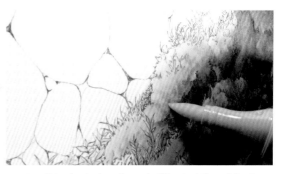

YG17 Grass Green — Extend the shadows. Apply YG17 as you drag out the color, all while thinking about the shape of the plant.

Y02 Canary Yellow — Extend color from the root of the plant. Repeat. Lastly, apply Y02 to add light.

Distinguish Between Light and Shadow

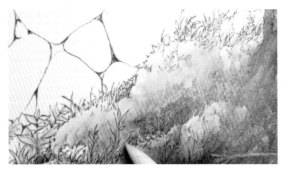

Y00 Barium Yellow — Add highlights to the bright areas.

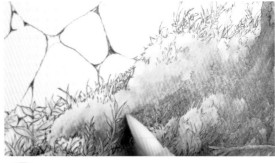

YG17 Grass Green **Y00** Barium Yellow — Overlay YG17 and blend. Then, remove some color using Y00.

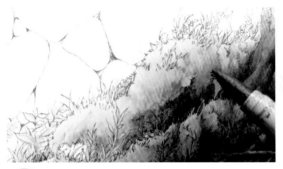

YG97 Spanish Olive — Make the shadows deeper. Stroke the brush in the direction of the flow of the plant and then overlay YG97.

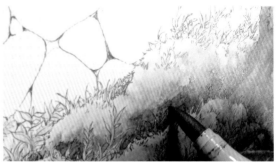

G99 Olive **YG17** Grass Green — While softening the dark shadows, overlay YG17 to make them even deeper.

To Finish

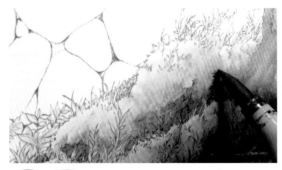

G99 Olive **YG17** Grass Green — Carefully overlay colors one-by-one in repetition. This is quite important.

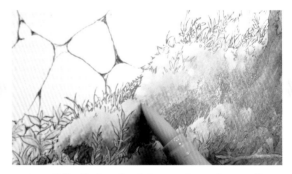

BG11 Moon White — Soften the boundary between yellow and green with BG11.

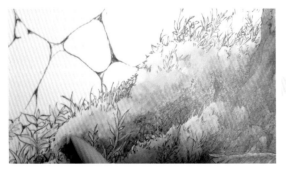

Y02 Canary Yellow **Y11** Pale Yellow — Add Y02 and Y11, mainly to the bright areas.

YG17 Grass Green — Add more shadows to complete.

Column
Techniques: How to Paint Plants

Moss-like Plants

Overlay a pale color and soften the base color.

When you add shadows always try to think of the overall shape as a group of circles.

← Add pale shadows at the center.

↖ Gradation with dots

Add fine shadows with the tip of the pen. Similarly, create gradations using just the tip of the pen.

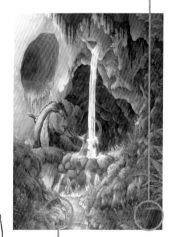

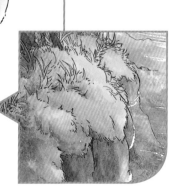

Plant Reflections on Shaded Areas

Create gradations in the shadow.

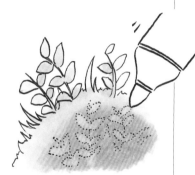

Use bright green to paint plants over the shadow. By doing so the outline of the plant will appear.

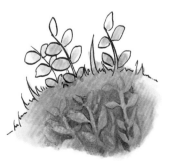

Add shadows along the outlined shape of the plant to complete.

Meadow with Thin Grass

The highlighted areas on these thin and tall grasses is expressed with outlines.

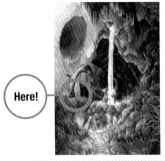

Here!

Before

After

Undercoloring

Y11
Pale
Yellow

Undercolor only the upper part of the grass because you only need to color those areas that are facing the light.

Y11
Pale
Yellow

Y00
Barium
Yellow

Apply in gradation.

0
Colorless
Blender

Blend in the gradation using #0 and the undercoloring is done.

Paint While Thinking About the Flow of the Grass

YG25
Celadon
Green

Paint the grass beginning with its roots.

YG25
Celadon
Green

Consciously make the tips of the grass pointy, but maintain the flow of the grass.

G24
Willow

Add a darker color, but make the strokes shorter than in the previous step.

Y15
Cadmium
Yellow

Add light to the grass.

Adding the Details

YG25 Celadon Green — Overlay YG25 on the grass.

YG67 Moss — Add shadows to the grass. First, apply YG67 lightly on the areas that face the light. Then, apply plenty of YG67 wherever there is shade.

YG17 Grass Green — Along the flow of the grass add YG17 with dots.

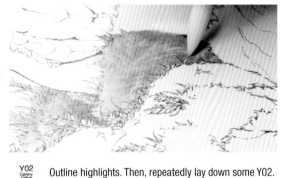

Y02 Canary Yellow — Outline highlights. Then, repeatedly lay down some Y02.

Finish Adding Light and Shadow

Y00 Barium Yellow — Add any light that is reflected by water.

YG67 Moss — Adding an area that has been completely filled with shadow brings out depth.

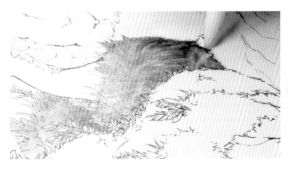

Y00 Barium Yellow **Y02** Canary Yellow — Outline the highlights.

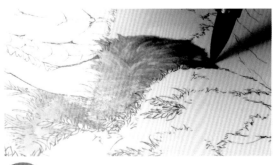

YG67 Moss **Y00** Barium Yellow — After adding more shadows adjust highlights.

 # Water Streaming Down the Stone Wall

For the water, begin by coloring the base color. For the stones, begin by adding shadows.

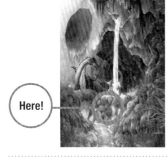

Here!

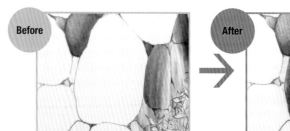

Before → After

▢ Begin by Coloring the Streams of Water

B0000 Pale Celestine
W6 Warm Gray No.6

Apply B000 to color the streams of water. Apply W6 on shaded areas beginning at the edge of the stone.

N3 Neutral Gray No.3

Overlay a slightly lighter shadow color.

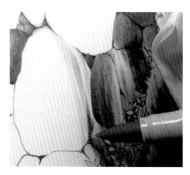

N2 Neutral Gray No.2

For water, apply a paler color (N2).

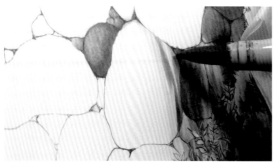

N4 Neutral Gray No.4

Paint around the flow of water. Be careful not to let anything jut out.

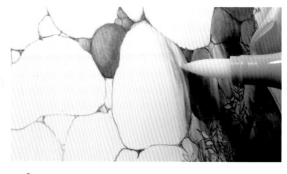

0 Colorless Blender

Add highlights to make the water more prominent.

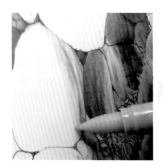

G00 Jade Green

Overlay G00 over the entire flow of water.

N3 Neutral Gray No.3 **N8** Neutral Gray No.8 **N4** Neutral Gray No.4 Add details.

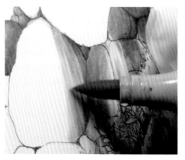

N2 Neutral Gray No.2

Apply N2 over everything to blend.

☐ Color the Stones

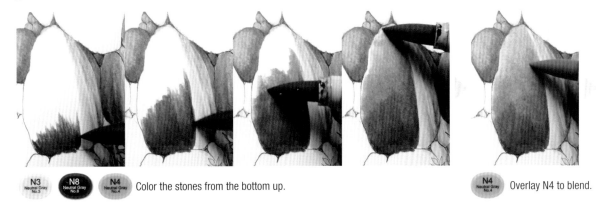

N3 Neutral Gray No.3 **N8** Neutral Gray No.8 **N4** Neutral Gray No.4 Color the stones from the bottom up.

N4 Neutral Gray No.4 Overlay N4 to blend.

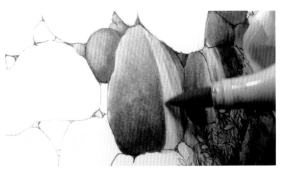

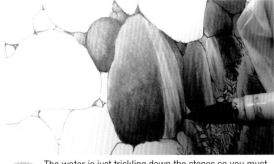

N3 Neutral Gray No.3 Be sure to make the edge of the flowing water distinct.

N4 Neutral Gray No.4 The water is just trickling down the stones so you must lightly render the portion of the stone that is visible behind the water.

☐ Incorporate Colors that Are Reflected on the Stone

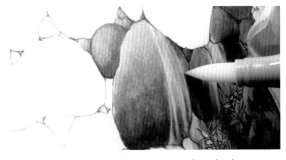
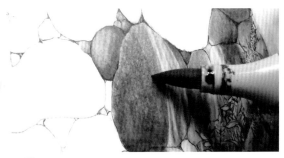

0 Colorless Blender Add highlights to the water as you lay color down on the stone.

YG95 Pale Olive Add a color with high green saturation (YG95) because the green of the grass is reflected here.

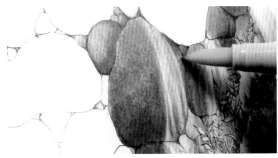
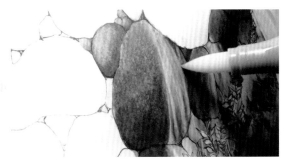

YG17 Grass Green **YG11** Mignonette Overlay YG17 and then apply YG11 to add unevenness. Repeat these steps.

0 Colorless Blender Add highlights to complete.

 # Cliff with Reflections of Light

The rock texture is produced by repeatedly overlaying color in a fine manner.

Here!

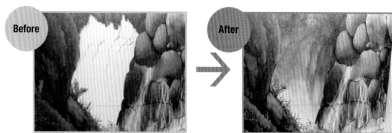

Before → **After**

⬛ Color the Foundation

W10 Warm Gray No 10 — First, lay down a dark shadow color.

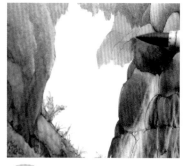

E84 Khaki — Simply overlay E84, without blending.

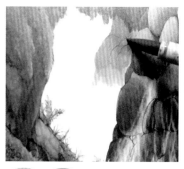

E84 Khaki **E35** Chamois — Overlay E84, and then blend in E35.

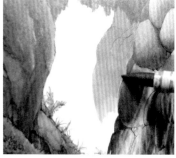

YG93 Grayish Yellow — Create gradations with a green color such as YG93.

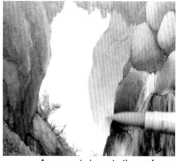

E41 Pearl White — As you get closer to the surface of the water the color becomes more pale.

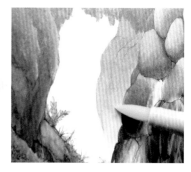

BG10 Cool Shadow — Adjust the overall shading.

⬛ Color the Rock Details

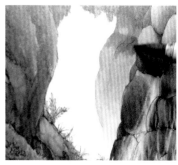

W4 Warm Gray No 4 — Add shadows to bring out the unevenness of the rock.

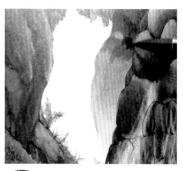

N9 Neutral Gray No 9 — Color the solid shape of the rock.

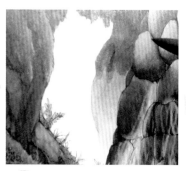

E84 Khaki — Overlay a color, like E84, for the shadows.

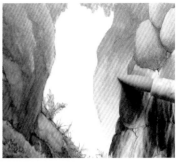

E41
Pearl White

Blend in a dark color with a pale color and create unevenness.

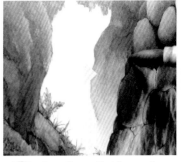

Y26
Mustard

Draw fine vertical lines and create the contours of the rock.

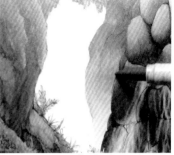

N3
Neutral Gray
No.3

N2
Neutral Gray
No.2

Render the contour of the rock again, but this time in different colors.

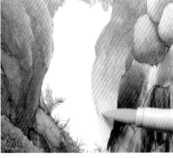

BG10
Cool
Shadow

Overlay blue water reflections across the colored area.

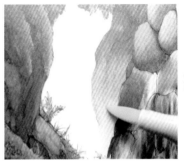

B0000
Pale
Celestine

Soften BG10 (the water reflection) using B0000.

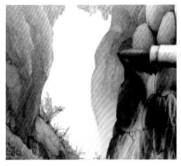

YG93
Grayish
Yellow

Create rock shapes while overlaying YG93.

⬛ Color While Considering Light

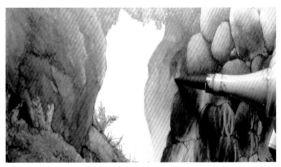

N6
Neutral Gray
No.6

After the undercoloring is finished, boldly apply N6. Pay attention to the fact that light is coming from the left.

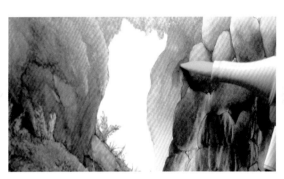

BG10
Cool
Shadow

Constantly soften N6 using BG10.

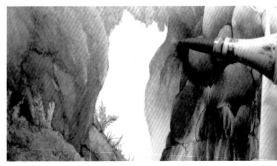

N6
Neutral Gray
No.6

Repeat these applications. Imagine the shape of the rock as you proceed.

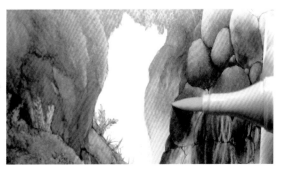

BG10
Cool
Shadow

Add highlights to the colored area using BG10.

☐ Adjusting Shadows

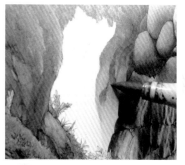

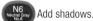 **N6** Neutral Gray No.6 Add shadows.

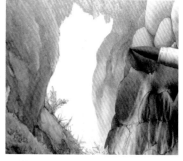

N3 Neutral Gray No.3 **BG10** Cool Shadow Blend only the shadows.

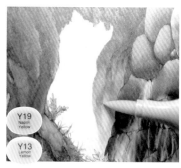

Y19 Napoli Yellow

Y13 Lemon Yellow

Y00 Barium Yellow Blend orange and yellow over the shadows to create gradation.

☐ Color the Rest of the Rock Wall

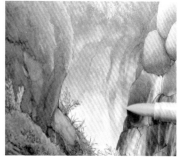

BG10 Cool Shadow Blend in green colored reflections (BG10) on the lower part of the wall.

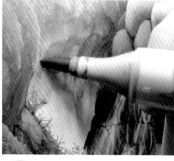

BG07 Petroleum Blue Start to lay down some blue shadows (BG07).

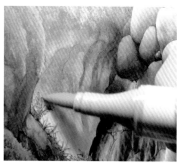

YG11 Mignonette As you blend in the blue shadows, apply YG11 on the entire lower section.

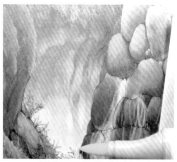

B000 Pale Porcelain Blue While constantly thinking about the unevenness of the rock surface, overlay a saturated blue color (B000).

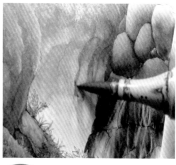

N6 Neutral Gray No.6 Add shadows on the wall.

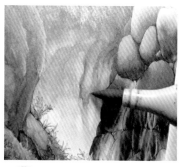

N4 Neutral Gray No.4 Blend in the shadows you just added using N4.

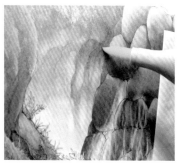

B0000 Pale Celestine Blend further as you add lighter blue (B0000).

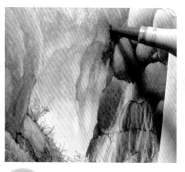

B04 Tahitian Blue Add blue (B04) to the shadows.

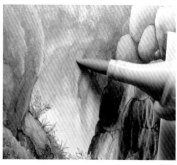

YG11 Mignonette Overlay YG11 where B000 is not applied.

Adjust the Details on the Rock Wall

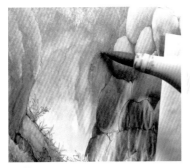

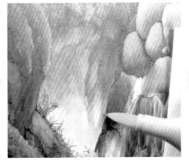

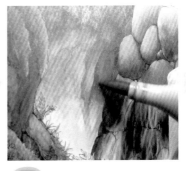

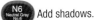 **N6** Neutral Gray No.6 Add shadows.

B000 Pale Porcelain Blue As you add shadows, soften them with B000.

B04 Tahitian Blue Add blue (B04).

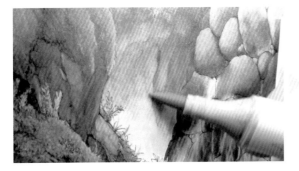

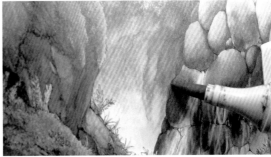

YG11 Mignonette Apply YG11 to blend in B04.

BG10 Cool Shadow **N3** Neutral Gray No.3 After you have finished coloring, add highlights to the darkest shadows by laying down some color (N3) within the shadow.

Blend in with the Surroundings to Finish

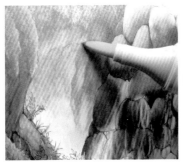

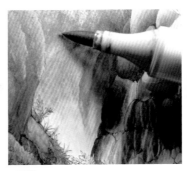

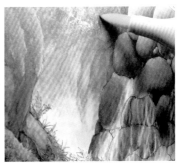

YG17 Grass Green Render light that is shining on the brown sections.

BG07 Petroleum Blue Add shadows to the cracks in the rocks.

B000 Pale Porcelain Blue Soften the shadows you just added using B000.

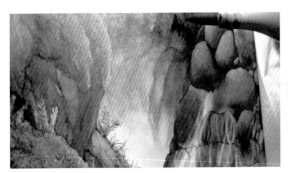

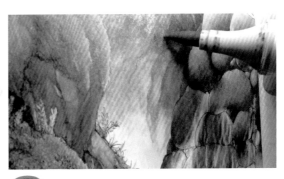

W6 Warm Gray No.6 Connect the shadows of the cracks and the shadows of the ferns.

N5 Neutral Gray No.5 Apply N5 where blue is prominent.

🔥 Clear Stream

B000 is frequently used here. We will overlay B000 repeatedly to create realistic water.

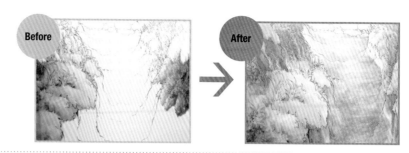

Here!

Before → **After**

▯ Decide on the Water Level

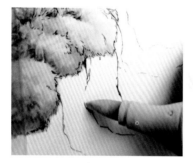

N2 Neutral Gray No.2 **N1** Neutral Gray No.1 Color the stones along the river bank.

B000 Pale Porcelain Blue In order to decide on the water level, draw a line along the river bank.

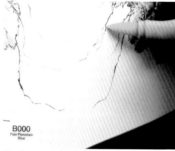

B000 Pale Porcelain Blue

Do the same for the opposite side. If you draw stones along the river bank the stream will appear to be clear.

▯ Color the Riverbed

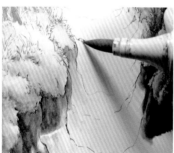

N2 Neutral Gray No.2 **N4** Neutral Gray No.4 Color underwater sections as you trace the riverbank.

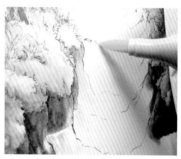

YG11 Mignonette Color stones on the riverbed in gradation.

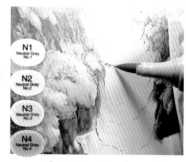

N1 Neutral Gray No.1
N2 Neutral Gray No.2
N3 Neutral Gray No.3
N4 Neutral Gray No.4

YG11 Mignonette Repeat the steps above and color more of the riverbed.

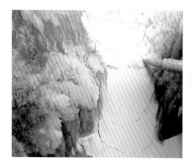

N0 Neutral Gray No.0 Undercolor using N0.

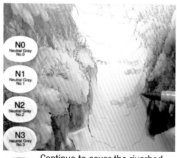

N0 Neutral Gray No.0
N1 Neutral Gray No.1
N2 Neutral Gray No.2
N3 Neutral Gray No.3
N4 Neutral Gray No.4 Continue to cover the riverbed and, as you move towards forefront, apply darker grays.

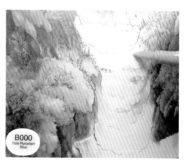

B000 Pale Porcelain Blue Color the water's surface. Light passes through water so you need color as if you are trying to create whiteness from your B000 marker.

⬚ Color the Riverbed

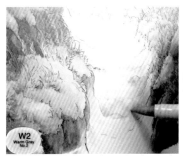

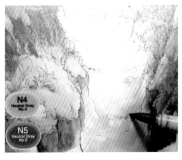

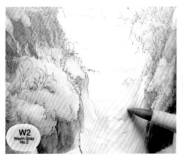

W2 Warm Gray No.2
B000 Pale Porcelain Blue
Add fine details on the riverbed stones. Then, soften those details by adding B000.

N4 Neutral Gray No.4
N5 Neutral Gray No.5
Repeatedly color the background more pale and the forefront more dark.

W2 Warm Gray No.2
Since these are riverbed stones you need to pay attention to their roundness and adjust the shape as necessary.

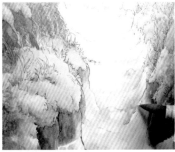

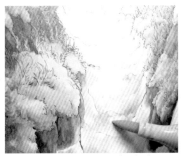

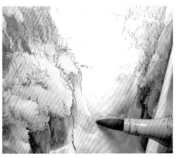

YG93 Grayish Yellow
In order to express moss on the riverbed just add some green-ish coloring (YG93).

E42 Sand White
In order to create riverbed sediment just apply E42 with uneven strokes of your marker.

YG93 Grayish Yellow
Blend in some YG93 to add fine details.

⬚ Color the Shallow Riverbed

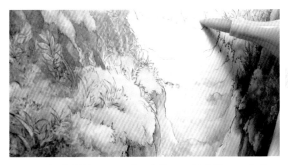

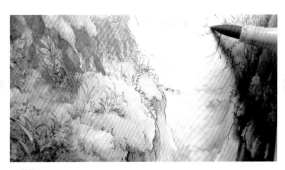

N1 Neutral Gray No.1
Apply N1 to express the shallow and bright areas in the riverbed.

N3 Neutral Gray No.3
Add shadows using N3.

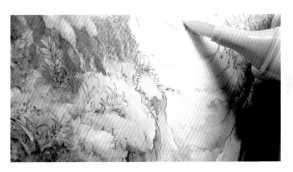

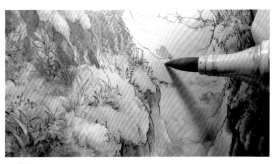

B000 Pale Porcelain Blue
Apply B000 to soften the edges of N3 you just applied.

YG93 Grayish Yellow
Overlay the riverbed color (YG93) and then add blue (B000) little by little. As you add blue, blend it with YG93.

Rendering Depth

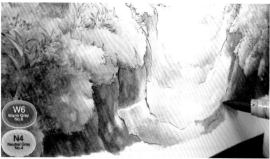

For the riverbed at the forefront apply W6 to create shadows, all the while grasping the position of each stone. Then, soften the shadows you just added by applying N4.

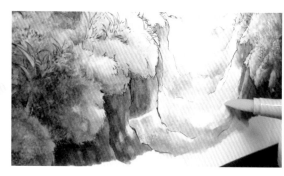

BG10
Cool
Shadow

Adjust the shadows by applying BG10.

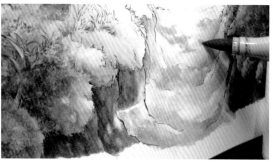

W6
Warm Gray
No.6

At the middle section of the riverbed, similar to the step above, apply W6 to color the shadows of the stones.

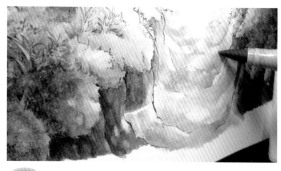

N4
Neutral Gray
No.4

Overlay N4 and create the shape of the riverbed.

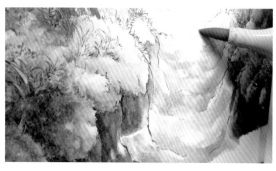

N2
Neutral Gray
No.2

Then, undercolor by mixing in the color of the sediment.

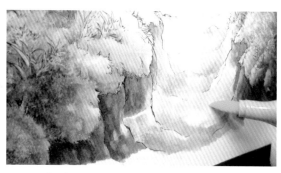

BG10
Cool
Shadow

Overlay blue (BG10) on the sediment color so that it recreates the transparency of the water's surface.

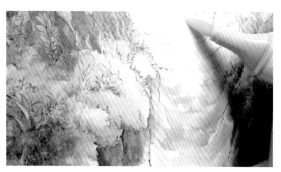

B000
Pale Porcelain
Blue

For the bright areas you just need to apply B000 to accentuate the shadows on the stones.

Adding Details to the Riverbed

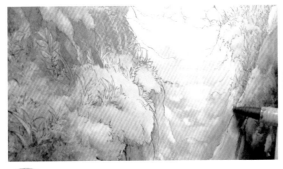

N4 Neutral Gray No.4 — Make the contours of the riverbed stones prominent.

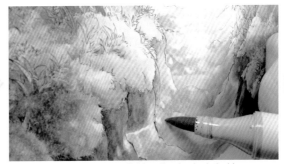

W4 Warm Gray No.4 — In order to express light on the riverbed, decide on the position of the light and then add emphasis to any surrounding objects.

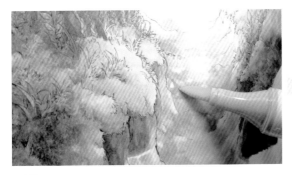

B000 Pale Porcelain Blue — Overlay B000 and adjust shading.

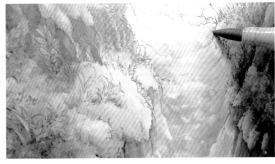

W4 Warm Gray No.4 — Similarly, add shadows in the shallow parts as you draw the contours of the stones.

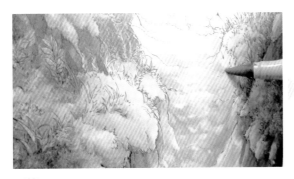

N2 Neutral Gray No.2 — Draw each stone one-by-one.

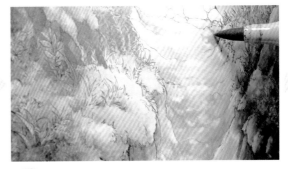

N3 Neutral Gray No.3 — The upper river is shallow, so apply N3 to create dark shadow on the stones.

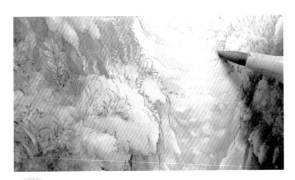

W2 Warm Gray No.2 — Apply N3 to blend.

□ Express Ripples on the Surface

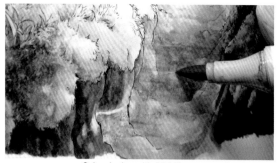

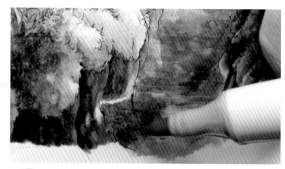

B23 Phthalo Blue **B000** Pale Porcelain Blue Color ripples with B23 like you are drawing horizontal lines. Use B000 to soften between the lines.

B04 Tahitian Blue Add accents on the riverbed in the forefront.

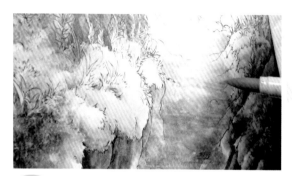

B04 Tahitian Blue Color ripples with fine horizontal lines.

N2 Neutral Gray No.2 Apply N2 to soften the B23 applied in the previous step. After applying B23 soften just the lower edge of the line right away. Do not soften the upper edge.

N4 Neutral Gray No.4 Draw a darker horizontal line.

B04 Tahitian Blue Soften and then draw. Repeat this process.

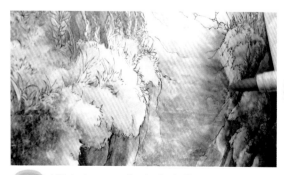

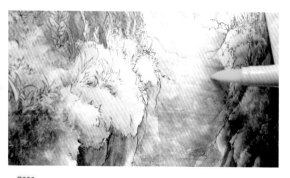

B04 Tahitian Blue Add shadows near the riverbank. This one also uses horizontal lines for coloring.

B000 Pale Porcelain Blue Move the marker horizontally as you blend with B000.

☐ Put Everything Together to Finish

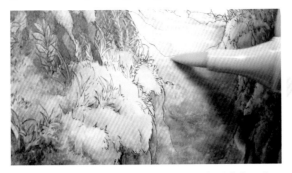

YG11
Mignonette
Add the yellow-green of the plants horizontally based on lighting.

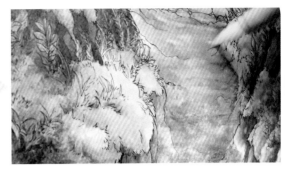

Y02
Canary Yellow
Add highlights that look like stepping-stones at the center of the river.

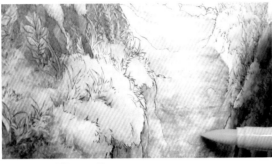

B23
Phthalo Blue **B04**
Tahitian Blue **N4**
Neutral Gray No.4 **B000**
Pale Porcelain Blue
Repeat the steps on the facing page.

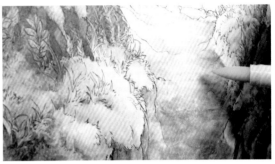

YG21
Anise **B000**
Pale Porcelain Blue
In the bright areas add color until there is a blue-ish tinge.

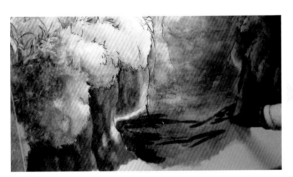

N9
Neutral Gray No.9
Add shadows to the darkest areas in the forefront.

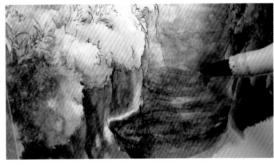

N9
Neutral Gray No.9
If you add too much color, the paper won't absorb the alcohol anymore and the colors will float.

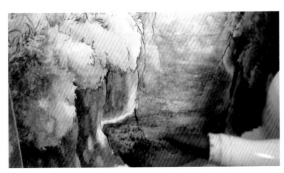

N9
Neutral Gray No.9
Move your marker horizontally while removing floating alcohol with your finger.

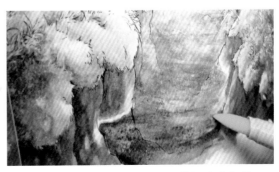

BG10
Cool Shadow
Rather than softening, just wipe off the alcohol with BG10. Lastly, add white ink to complete.

🔥 Dragon Scales

It is labor intensive but it is crucial to finely color the scales.

Here!

Before

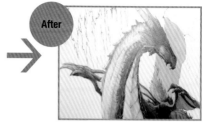

After

⬚ Create the Base of the Neck

B37 Antwerp Blue — Draw the contours of each scale piece-by-piece.

B05 Process Blue — Color over the drawn contours. It is not necessary to soften the colors here.

B06 Peacock Blue — Color over even more.

B95 Light Grayish Cobalt — Overlay B95 and soften the colors.

B05 Process Blue — Then color further in gradation.

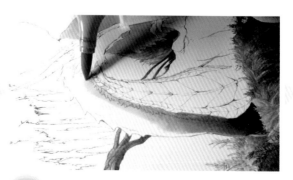

BG53 Ice Mint — Further, paint pale colors in gradation.

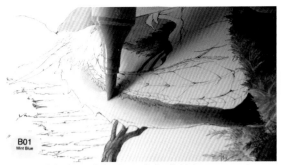

B01 Mint Blue

B02 Robin's Egg Blue

Paint in gradation towards the light. Leave rugged, uneven brush strokes because this part will turn into scales.

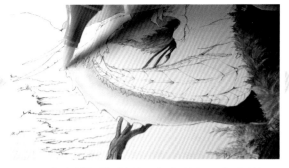

Y02 Canary Yellow

Apply Y02 while thinking about which way the light is facing.

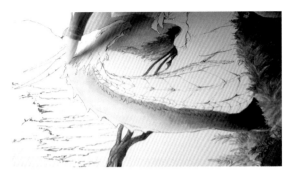

Y00 Barium Yellow

Blend the bright areas and the blue of the dragon.

Adding the Details

B37 Antwerp Blue

Paint a shadow on the upper part of the dorsal spine.

B05 Prussian Blue

Finally, blend. Purposefully leave uneven brush strokes to bring out the rugged feel of the dorsal spine.

Y15 Cadmium Yellow

Like a dot painting, overlay the color in gradation by pressing the nib against the paper.

B37 Antwerp Blue

B06 Peacock Blue

B05 Prussian Blue

B02 Robin's Egg Blue

Add shadows on the dorsal spine in such a manner that the color gradually becomes pale towards the lower section.

Y17 Golden Yellow

Apply Y17 from the bottom of the dorsal scale to make it appear as though light is shining on it.

☐ Adding Details While Thinking About Light

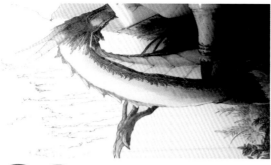

 B37 Antwerp Blue **B06** Peacock Blue Draw shadows on the scales in detail.

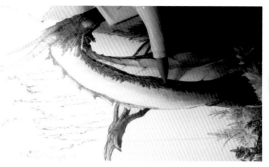

G21 Lime Green This part doesn't face the light very much so just use G21 to express light.

 B06 Peacock Blue Draw the scales on the side. Draw using fine lines.

G00 Jade Green Since a strong light is shining on this section, apply G00 and blend.

BG53 Ice Mint Overlay light along the contours of the scales. Bright areas are expressed by thinning the lines of the scales.

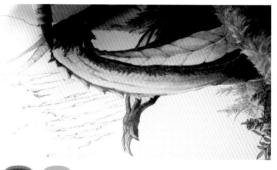

B06 Peacock Blue **B05** Process Blue Intently draw the scales using fine lines.

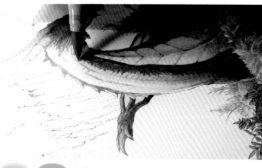

 BG53 Ice Mint **B05** Process Blue Soften the lines of the scales to make them not stand out.

B05 Process Blue **BG53** Ice Mint **G00** Jade Green Blend B05 in the dark areas. Then blend in G00 on the bright areas. Also, blend in BG53 between the dark and the bright.

⬛ Refine the Details to Finish

 B000
Pale Porcelain Blue
Further soften the lines of the scales.

B37
Antwerp Blue
Add shadows on the scales in order to add more detail.

B05
Process Blue
Soften the shadows that you just added.

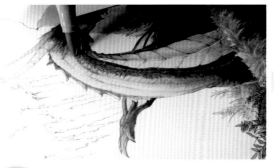

BG34
Horizon Green
Lay down a different color (BG34) and blend.

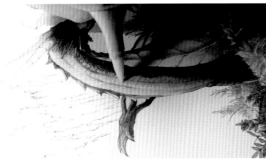

G00
Jade Green
Apply G00 on the bright areas and blend.

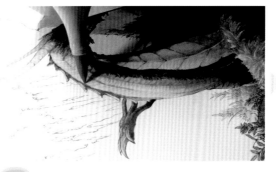

BG53
Ice Mint
Lay BG53 on the scales along the outside edge.

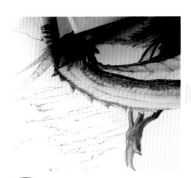

B37
Antwerp Blue
Add shadows from the outside to the inside.

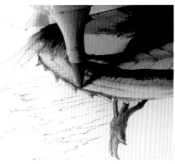

B05
Process Blue
Soften the shadows that you just added.

B37
Antwerp Blue
Repeat the steps above until you achieve your intended image.

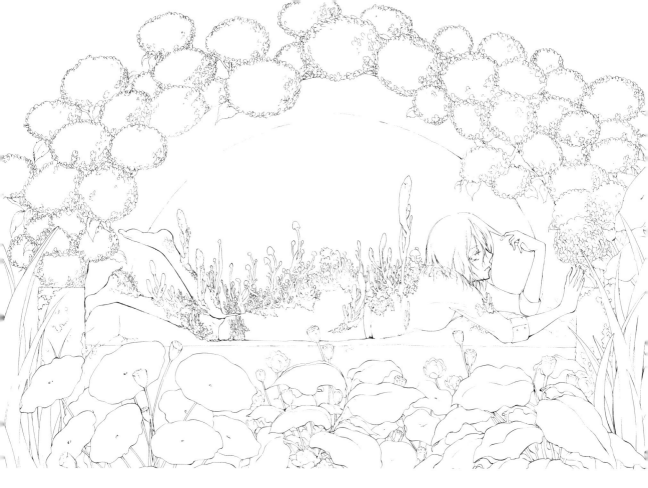

Scene 3
Human Plant

Caterpillar Fungus

Caterpillar fungus is a parasite that lives in larva during winter. Taking nutrients from the larva, it produces a mature body in summer. This larva, however, lives in people! The steps for rendering scenery with continuously drizzling rain, as well as tropical plants such as hydrangea, are provided next.

Rough Sketch

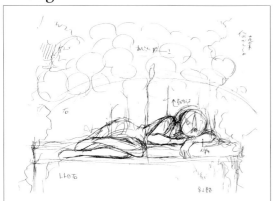

This rough sketch is created by outlining a human figure, the foreground, and some plants. Initially there were flowering trees in the background and I had an image of a sleeping human figure surrounded by plants.

Outline

In this sketch, the flowering trees are still in the background but they are now less prominent and the figure now lies playfully on her stomach. I tried to incorporate everything just using COPIC Markers.

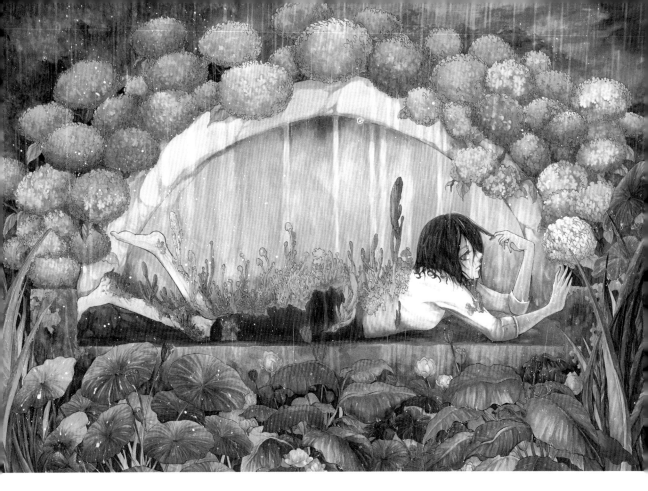

Illustration Points

 Hydrangea in Full Bloom

P.124

 Rain Dropping on a Lotus Leaf

P.118

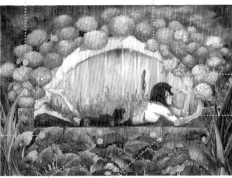

P.122

Moist Tropical Plants

P.136

Wet Shirt

 Wet Hair

P.132

P.128

 Rain Dripping Down Skin

P.134

Skin Under Pale Light

▍Planning Light and Shadow

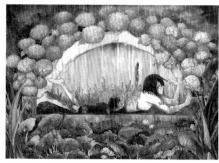

🌸 Rain Dropping on a Lotus Leaf

Color lush leaves that have fine veins.

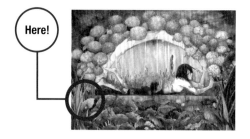

Here!

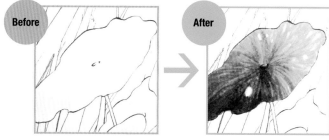

Before → **After**

▍Undercoloring

B00
Frost
Blue

Draw drops of water that have become round due to surface tension.

G28
Ocean
Green

Draw veins moving out from the center.

YG11
Mignonette

BG11
Moon
White

Color between the veins. Apply BG11 to the shaded areas.

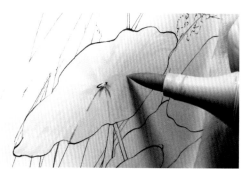

YG11
Mignonette

Begin to draw veins on the leaf.

Color the Veins of the Leaf

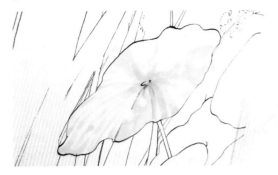

YG11 Mignonette Apply the same vein color across the entire leaf.

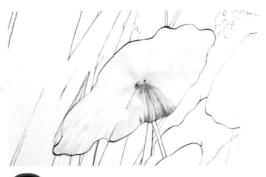

G28 Ocean Green Finely color veins from the center to the edge.

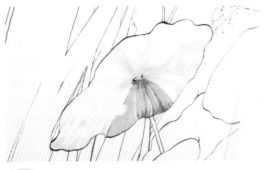

YG25 Celadon Green Soften the area between the veins.

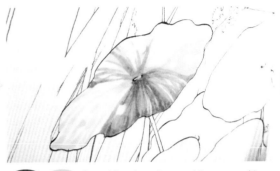

G28 Ocean Green **YG25** Celadon Green Repeat the steps above and then proceed to color the leaf.

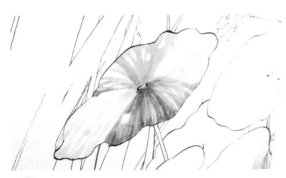

YG25 Celadon Green Use a lighter color for the upper part of the leaf.

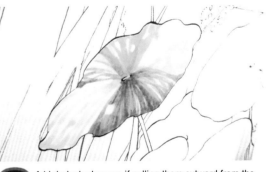

G94 Grayish Olive Add dark shadows as if pulling them outward from the center.

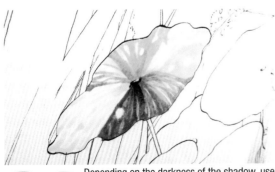

YG17 Grass Green **YG25** Celadon Green Depending on the darkness of the shadow, use either YG17 or YG25 to blend. Pay attention to the direction of the light.

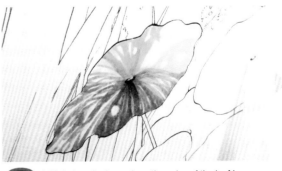

G94 Grayish Olive Add darker shadows along the veins of the leaf in a similar manner.

Color the Leaf

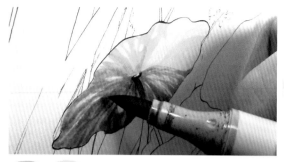

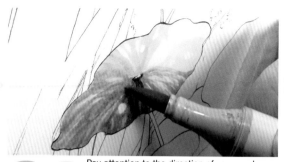

YG17 *Grass Green* **YG25** *Celadon Green* Paint toward the outside of the leaf from the center.

YG17 *Grass Green* **YG25** *Celadon Green* Pay attention to the direction of your marker strokes. Always stroke from the center outward.

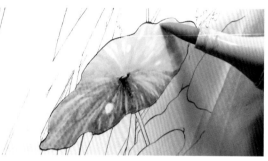

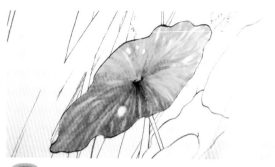

BG11 *Moon White* In order to add thickness, lay down BG11 on the upper part of the leaf.

YG17 *Grass Green* Continue to add shadows.

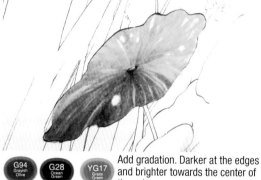

YG17 *Grass Green* Paint the leaf but leave the lines of the veins.

G94 *Grayish Olive* **G28** *Ocean Green* **YG17** *Grass Green* Add gradation. Darker at the edges and brighter towards the center of the veins.

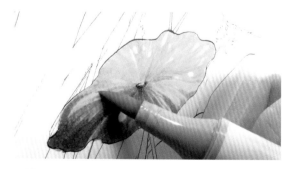

BG11 *Moon White* Apply BG11 on the areas where the leaf curves.

Improving the Details

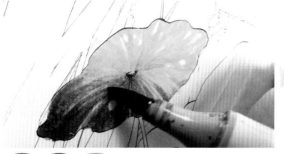

 Overlay the indicated colors.

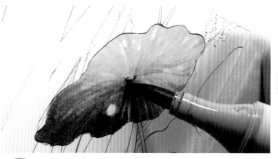

Add some dark shadows.

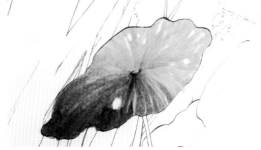

 Blend some G28 over the dark shadows and then add YG17 to make gradations.

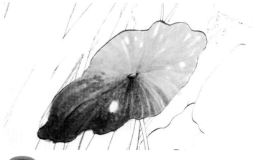

Add stains on the leaf.

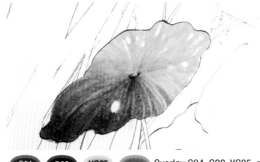

 Overlay G94, G28, YG25, and YG17. Blend as you apply them.

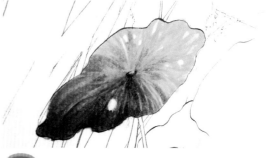

Lay YG93 over the bright areas.

To Finish

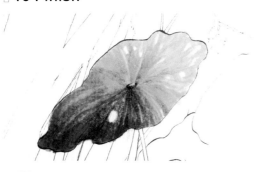

YG11 Mignonette Blend YG11 over everything.

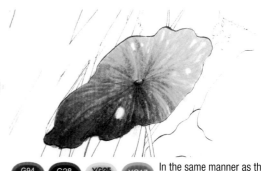

 In the same manner as the steps above, darken the shadows and add more detailing to complete.

 # Moist Tropical Plants

Create a leaf that is smooth to the touch.

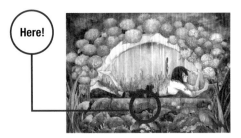

Here!

Before

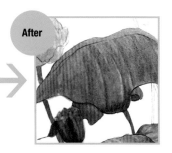

After

Undercoloring

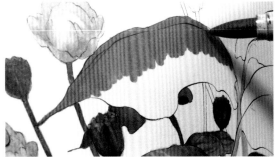

RV17 Deep Magenta — Color the plane that faces the light.

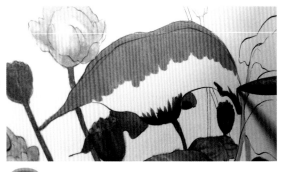

YG63 Pea Green — Color upward from the bottom edge.

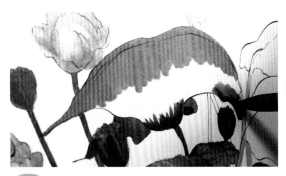

YG17 Grass Green — Similarly, blend in YG17 from the bottom edge.

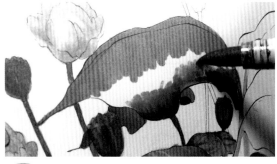

YG63 Pea Green — Blend YG63 over everything. Similarly, stroke the marker up from the bottom edge.

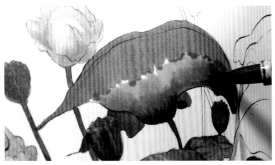

YG17 Grass Green — Adjust the shading. Similarly, begin from the bottom edge.

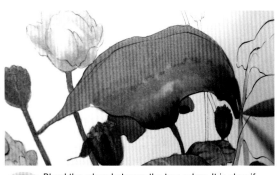

R21 Sardonyx — Blend the edges between the two colors. It is okay if some unevenness remains.

Raise the Veins of the Leaf

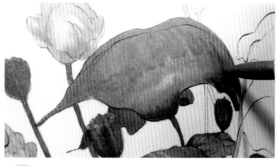

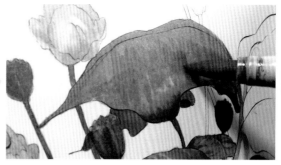

YG25 Celadon Green — Draw the veins of the leaf.

R85 Rose Red — Add vein shadows.

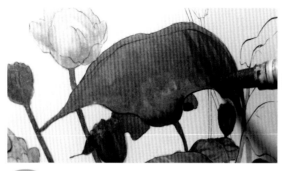

YG17 Grass Green — Overlay shadows.

R85 Rose Red — Again, draw veins on the leaf.

G94 Grayish Olive **YG17** Grass Green — Move your markers up and down along the veins when overlaying the listed colors.

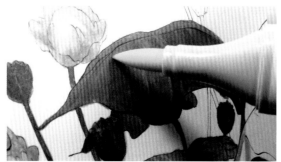

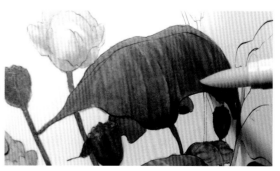

G20 Wax White — Remove some color from the lower part of the veins in order to make the shape of the leaf more distinguishable.

V0000 Rose Quartz — Remove some colors from the upper part of the veins in order to make the veins more distinguishable.

Hydrangea in Full Bloom

Add some large, round hydrangeas. In this section we will use three different colored hydrangea.

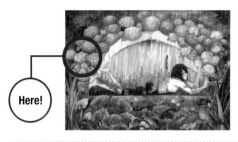

Here!

Before

After

Rough Undercoloring

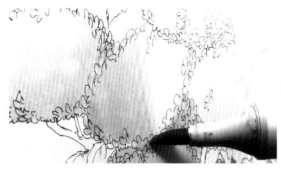

BV20 Dull Lavender — Start with some rough undercoloring. It is okay if there are uneven brushstrokes.

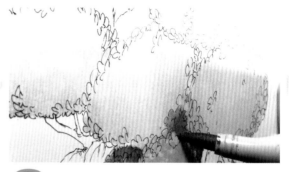

BG57 Jasper — Undercolor the shaded areas between the hydrangeas.

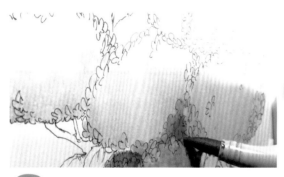

BG57 Jasper — After it has dried, apply BG57 again.

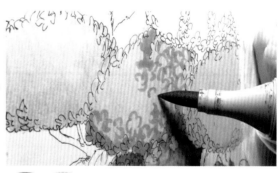

BV13 Hydrangea Blue **BV02** Prune — Draw shadows on the petals using BV13 while thinking about the overall shape of the petals.

BV13 Hydrangea Blue **BV02** Prune — Paint the shape of the petal while making gradations.

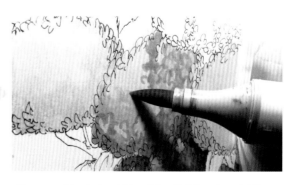

Allow everything to dry at this point so that the colors stabilize.

Improving the Details

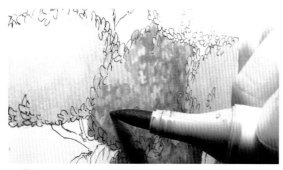

V22
Ash Lavender

Soften the outlines of the petal (shadow).

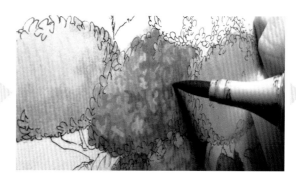

For example, repeatedly add shadows by overlaying V22.

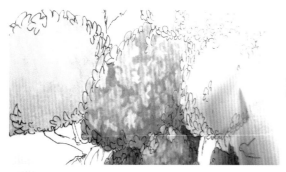

BV20
Dull Lavender

Lightly drop in some BV20 to lighten the shadows here and there.

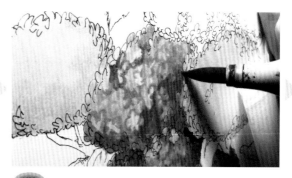

V22
Ash Lavender

Next, solidify the shadows.

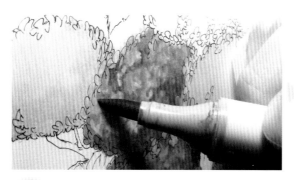

BV20
Dull Lavender

Blend the overall shading.

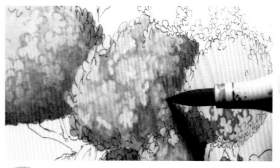

V22
Ash Lavender

Apply V22 only on the shadows to make the shape of the petals pop.

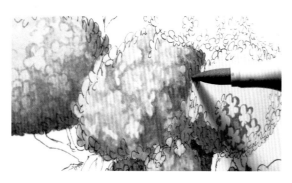

Bring the details together to complete.

Create a Green-ish Hydrangea

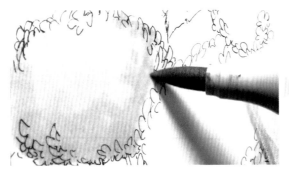

BV20 Dull Lavender — Undercolor. Once it has dried, apply some more undercolor and create shadows as well.

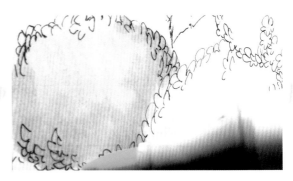

YG11 Mignonette — Apply YG11 over the hydrangea to make it green.

BV04 Blue Berry — Apply BV04 from the bottom toward the top and make gradations.

BV20 Dull Lavender — Apply BV20 over the BV04 to blend. Purposefully use uneven brushstrokes to create a rough surface.

BG23 Coral Sea — Color the areas facing the light. Decide on the size of the area while taking into account the roundness of the hydrangea.

B01 Mint Blue — Apply B01 over everything and blend for overall shading. I recommend leaving some unevenness here.

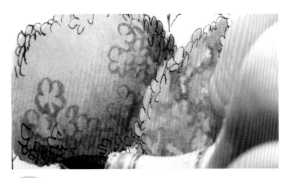

B95 Light Grayish Cobalt — Draw the petals.

Red-purple Hydrangea

BV20 Dull Lavender — Roughly undercolor in the same manner as the other two hydrangeas.

BV04 Blue Berry — Draw shadows in the shape of a petal.

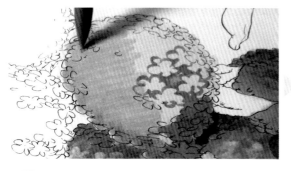

V01 Heath — Apply V01 roughly on the areas facing the light.

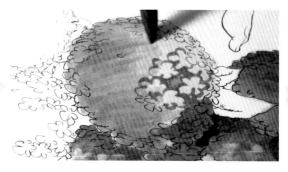

V01 Heath — Overlay V01.

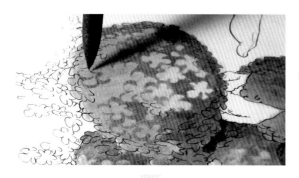

V05 Azalea — Draw shadows in the shape of the petal.

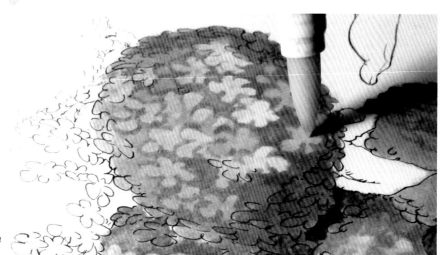

Y13 Lemon Yellow — Apply Y13 to the center of the petals to add highlights.

 # Rain Dripping Down Skin

Create a face that is wet with rain and has rain drops streaming down its cheeks.

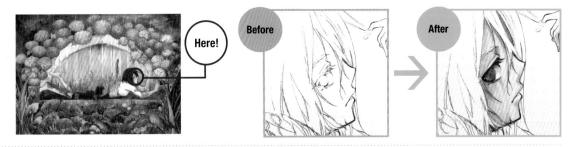

▌Undercoloring

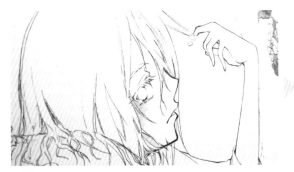

B21 *Baby Blue* Apply the shadow color first.

YR20 *Yellowish Shade* Overlay the skin tone color (YR20) and blend it with the shadow.

YR20 *Yellowish Shade* Apply YR20 over the entire face, including the area you already painted.

B21 *Baby Blue* Now that the undercoloring on the face is done, add shadows.

V01 *Heath* Add redness on the face.

E34 *Toast* Add solid shadows.

Improve the Details by Adding Shadows

B60 Pale Blue Gray — Soften the edges of the shadows.

V04 Lilac — Add the shadow color to the deeply shaded areas, including around the eyes.

V01 Heath — Lay down some V01 while blending the shadows.

V01 Heath — Add a shadow to the nose.

V04 Lilac — Darken the shadow at the base of the nose and then make it paler toward the tip of the nose.

V01 Heath — Blend in the shadow.

YR20 Yellowish Shade — Blend the skin color and the shadow together well.

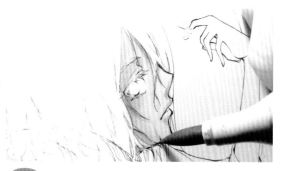

E35 Chamois — Add a solid shadow along the chin.

A Drop Running Down the Cheek

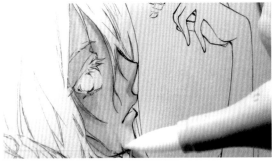

0
Colorless
Blender

It is raining so we will use #0 to add a highlight to create the image of a drop of water.

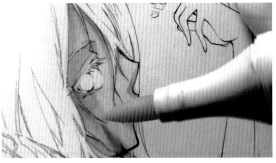

YR20
Yellowish
Shade

Blend YR20 along the outside edge of the highlight in gradations.

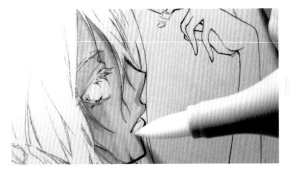

Add the trace of the water drop in a similar manner.

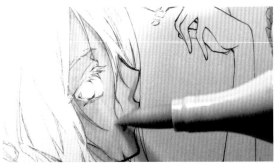

T2
Toner Gray
No.2

In the same manner as above, blend T2 along the inside edge of the highlight in gradation.

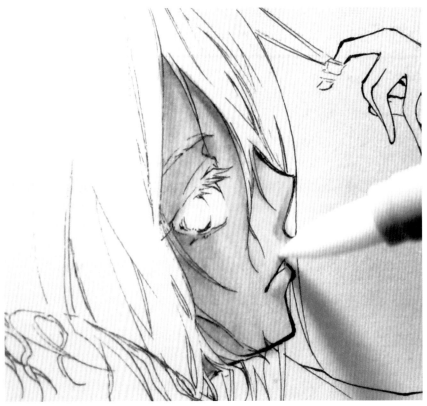

Add highlights to make the water look like it is dripping down around the mouth.

Color the Eye

W9 Warm Gray No 9 — Add an eye-line.

V12 Pale Lilac — While taking off some of the eye-line color applied in the previous step, add a shadow around the eye.

V000 Pale Heath — Blend the shadow in order to bring out the roundness of the eyeball.

BV20 Dull Lavender — Continue to blend in the shadow.

V09 Violet — Color the center of the pupil and the iris.

RV34 Dark Pink — Lay RV34 over the entire pupil.

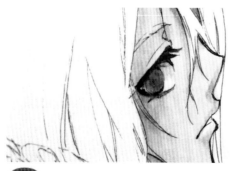

V17 Amethyst — Use the tip of the brush to paint the iris once again.

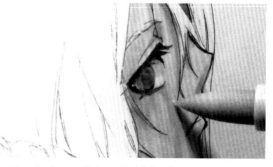

N1 Neutral Gray No 1 — Lastly, use N1 to add highlights along the water drop once more.

❀ Wet Hair

This hair is wet with rain and glowing under ambient light.

Here!

Before → **After**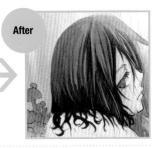

❘ Begin to Color the Shaded Area Along the Flow of the Hair

RV34 Dark Pink — Begin with the area under ambient light. Color along the curve of the skull.

E84 Khaki — Apply E84 on the shadow at the base of the neck. Then blend in with the hair color. Move the brush in an up-and-down motion along the curve of the skull.

E84 Khaki — Apply E84, except for the areas containing RV34, to color the hair.

RV34 Dark Pink — Overlay RV34 and blend in with the hair color.

E29 Burnt Umber — Color the deepest shadows on the hair.

E84 Khaki — Apply E84 to the hair along the curve of the skull.

Add Color While Considering the Angle of the Light

RV34
Dark Pink

Repeatedly apply RV34 to the shaded areas until the red becomes visible.

Light appears in a curved line on the hair. Consider the curves of the head, like in the picture above.

E29
Burnt Umber

Add dark shadows.

Let this dry for a short while.

E29
Burnt Umber

Again, add shadows along the curve of the skull.

E29
Burnt Umber

Do the same around the face.

E29
Burnt Umber

Color out to the ends of the hair.

Skin Under Pale Light

Under pale light skin has blue shadows.

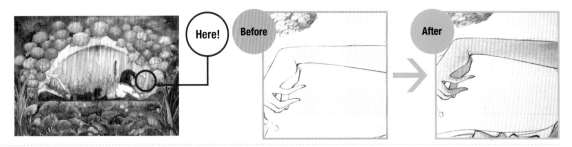

Here! Before → After

Create Foundation Shading

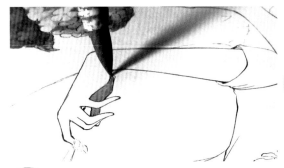

RV34 Dark Pink — Undercolor a shadow.

B01 Mint Blue — Add B01 to create a purplish color.

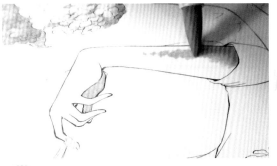

V12 Pale Lilac — Add redness (V12) to the shaded area of the arm.

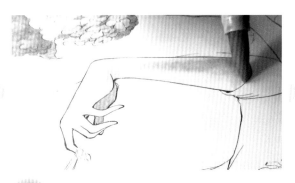

V01 Heath — Apply V01 over the V12 and blend.

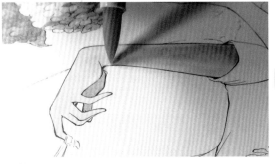

YR20 Yellowish Shade — Soften the edges of the shadow while applying skin color.

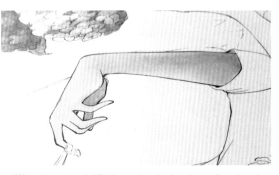

YR20 Yellowish Shade — Do not apply YR20 over the shadow, just soften the edge of the shadow.

Blend the Shadow While Thinking about the Shape of the Arm

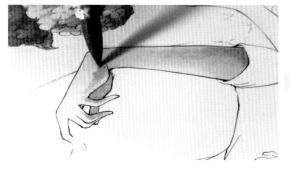

V12
Pale Lilac

Apply V12 to add a shadow on the palm of the hand.

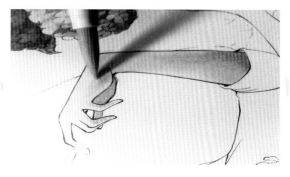

V01
Heath

Overlay V01 and then blend.

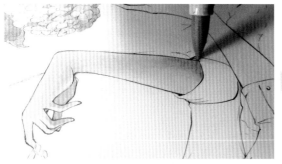

BV20
Dull Lavender

Create the roundness of the arm with a shadow, blending all the while.

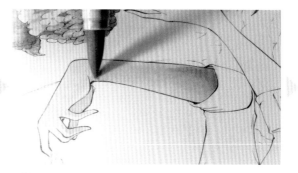

B01
Mint Blue

Apply B01 over BV20 and blend.

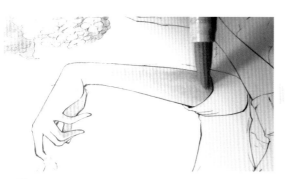

V01
Heath

Overlay V01 on the shadow.

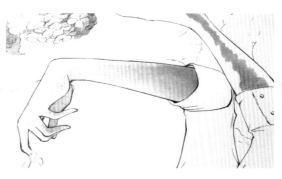

Do the same for the other arm.

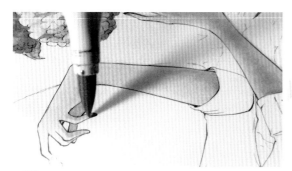

R85
Rose Red

Add redness on the fingertips to complete the complexion. The left arm is complete!

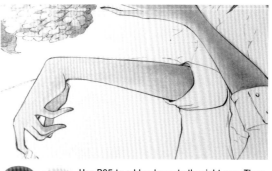

R85
Rose Red

V01
Heath

Use R85 to add redness to the right arm. Then blend in V01 to complete.

Wet Shirt

The impression of a wet shirt is created by the shape of the shadows and how they are cast.

Use Colorless Blender

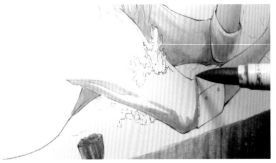

N4
Neutral Gray No.4
Undercolor the shadow of the clothes. The fabric of the clothes is thick so you need to make creases thick.

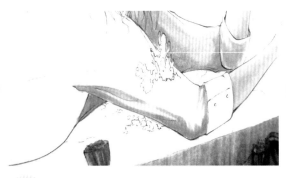

V01
Heath
Overlay V01 and blend it in a little.

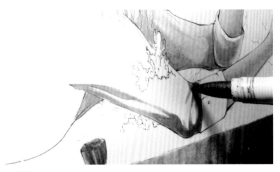

V95
Light Grape
Finely apply V95 to add shadows.

N4
Neutral Gray No.4
Continue to add shadows.

0
Colorless Blender
Add highlights and soften the edges of the shadow.

N1
Neutral Gray No.1
Blend in N1 and deepen the details.

⬚ Coloring the Details on the Sleeve

N4 Neutral Gray No.4 — Color the shadow on the cuff. Slide the marker from edge to center.

V0000 Rose Quartz — Overlay V0000 and soften the edges of the shadow.

V01 Heath — Overlay V01.

V12 Pale Lilac — Further, overlay V12.

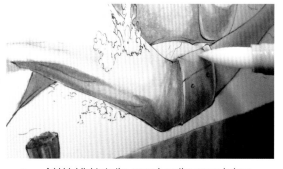

 N3 Neutral Gray No.3 — Apply N3 and blend everything.

0 Colorless Blender — Add highlights to the area where the crease bulges. Doing so will produce a wet and glossy texture.

Point: **Add Expression to the Rain Using Colorless Blender**

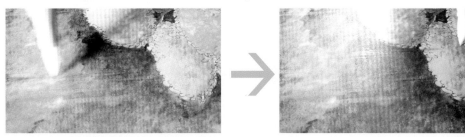

Add highlights to further express rain. Move the brush strongly, quickly, precisely, and blend in other colors. Doing so creates realistic looking rain.

Scene 4

Princess with
the wind

Dancer

This is an image of a Japanese-style opera. The morning sun beams into an opera house where cherry blossoms are in full bloom and the light shines on the actress on stage. In this section I explain how to create texture for cloth that flutters in the wind, cherry blossoms in the background, and the morning sky.

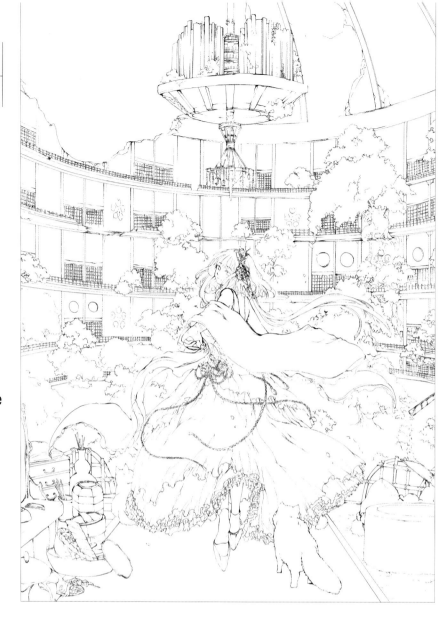

❙ Rough Sketch

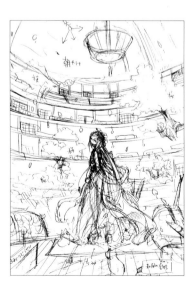

One of the themes that I had in my mind for this drawing was "Japanese-style." So, I thought hard about a Japanese-style opera house. I had a solid image from the moment I began the rough sketch.

❙ Outline

It doesn't look very precise but this is indeed my completed rough sketch. From here I used COPIC markers and drew directly over the rough sketch.

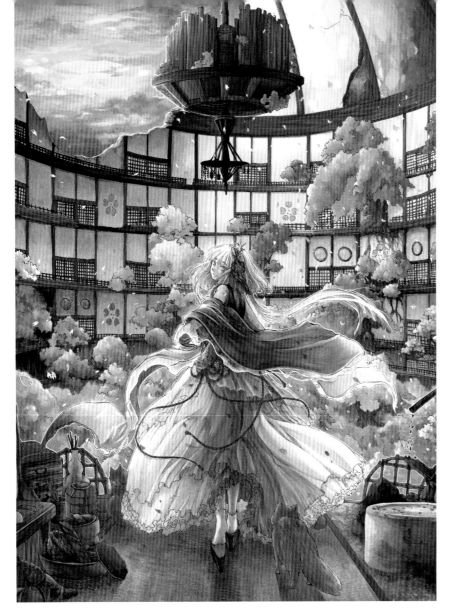

Illustration Points

Morning Glow

P.148

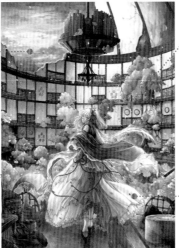

Sliding Doors

P.146

Cherry Blossoms
in the Background

P.140

P.142
Dress Flowing in the Wind

▌Planning Light and Shadow

Morning glow ... 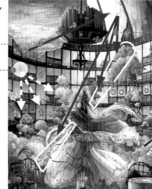 ... Reflections from the dome

Imagined light source .. Appears yellow-ish due to reflections

😄 Cherry Blossoms in the Background

Inside the opera house cherry blossoms are in full bloom. Color the cherry blossoms in a pale light.

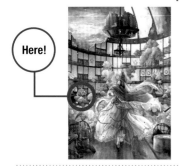

Here!

Before

After

▐ Undercoloring

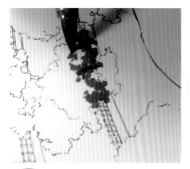

B28 Royal Blue — Color the shaded area as if dot painting.

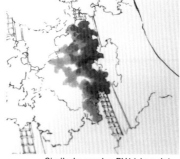

BV11 Soft Violet — Similarly, overlay BV11 in a dot painting manner. Then, blend with the shadow.

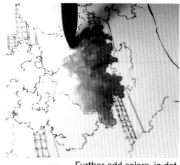

V01 Heath **BV11** Soft Violet — Further add colors, in dot painting manner, over the shadow. Then, blend in.

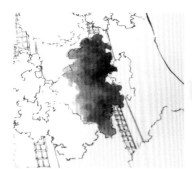

E04 Lipstick Natural — In order to add redness, apply a little E04 on the V01 applied to the shadow.

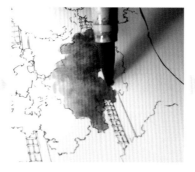

Repeatedly apply E04 to bring out depth.

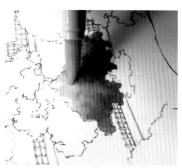

V01 Heath — Blend in V01 to adjust the overall shading and complete the undercloloring.

▣ Finishing

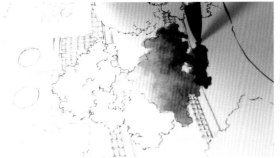

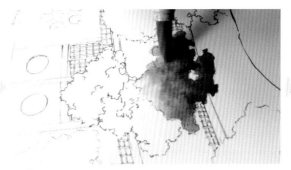

 B28 Royal Blue **E04** Lipstick Natural — After dropping in some deep shadows using B28, overlay with E04 to ease those shadows. For this process also keep in mind that you are dot painting.

BV11 Soft Violet — Overlay BV11 from the bottom to the top of the blossoms.

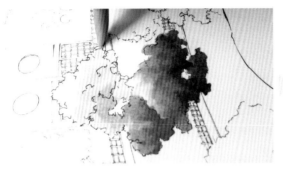

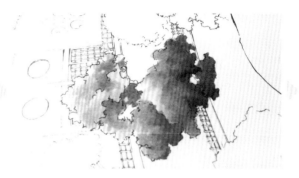

V01 Heath — The bright area, filled with V01, is slightly wider but otherwise it is basically the same.

So far, we have painted this much.

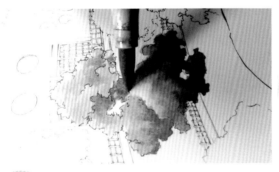

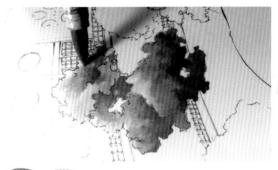

BV11 Soft Violet — Soften the edges of the shadow.

E04 Lipstick Natural **BV11** Soft Violet — Add shadows in the bright areas and blend.

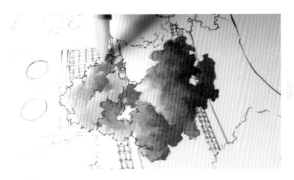

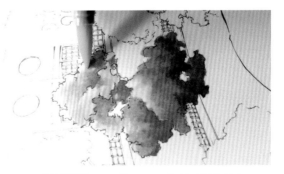

Y11 Pale Yellow — Lastly, apply highlights.

BG10 Cool Shadow — Add BG10 because the area under the highlights is slightly shaded.

🎭 Dress Flowing in the Wind

In the morning glow the white dress looks pale pink because the color of the cherry blossoms permeates the dress through back-lighting.

Here!

Before

After

⬜ Start with the Shaded Plane

BV31 Pale Lavender **W5** Warm Gray No.5 Apply BV31 in the indented areas that are facing the light and apply W5 on the shaded areas that are curved.

W5 Warm Gray No.5 Add shadows.

BV04 Blue Berry Apply BV04 to blend the bright areas and shaded areas.

N5 Neutral Gray No.5 Apply N5 over the bright areas to bring out the color of the shadows.

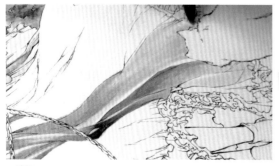

BV31 Pale Lavender Overlay BV31 in such a manner as to extend the shadows applied in the previous step.

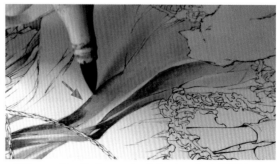

BV13 Hydrangea Blue **BV31** Pale Lavender Further overlay dark colors. Apply BV13 in an inverted "U" shape and then apply BV31 inside of the "U" in gradation.

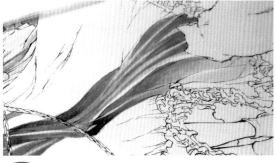

 Precisely add shadows to create the "drape"-like base of the dress.

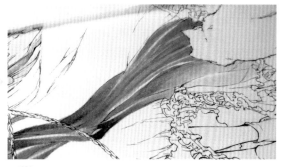

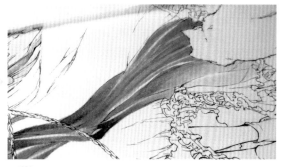 Apply W1 over the shadows to give finishing touches.

Paint the Hem

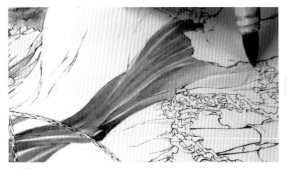

 Apply BV31 in the areas with the deepest shadows.

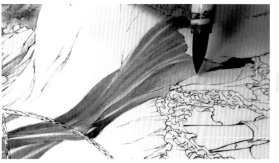

 Lay W8 thickly over areas where you applied BV31.

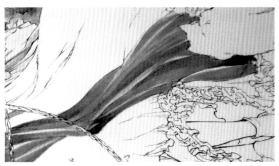

 As you expand the shaded areas blend them in with the areas that you already painted.

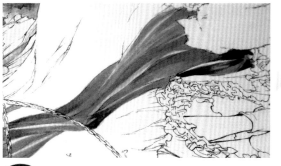

 Further, apply W8 to emphasize any interior creases.

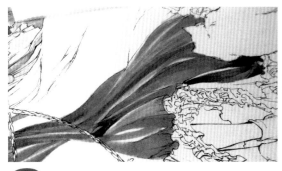

 Continue to paint shadowed areas.

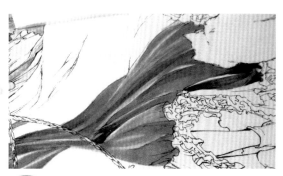

 Apply BV13 over everything to settle the shading.

⬚ Color the Planes Facing the Light

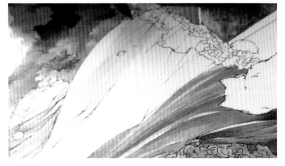

BV31
Pale
Lavender

Apply the shadow color (BV31) to the furthest areas of the dress.

V01
Heath

Over BV31 that was just applied, lay down some V01 to reflect the cherry blossoms.

0
Colorless
Blender

As you blend in the color applied in the previous step using #0, leave the curved areas unpainted as a highlight.

E40
Brick
White

Draw the fabric crease shadows.

V01
Heath

Overlay the cherry blossom color (V01) on the shadows drawn in the step above and blend.

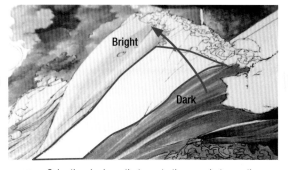

E40
Brick
White

Color the shadows that create the gaps between the curves of the fabric and the shaded parts.

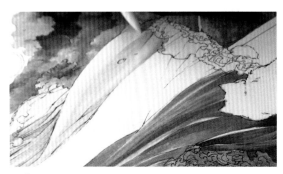

0
Colorless
Blender

Using #0, blend all of the shading.

⬚ Paint the Middle Section

N5 Neutral Gray No.5 — First, paint a shadow. Create uneven brushstrokes vertically to bring about a wrinkled feel.

BV31 Pale Lavender — Apply BV31 over the shadow and blend.

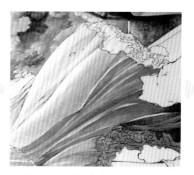

V01 Heath — Apply V01 to blend in other areas, except the highlights.

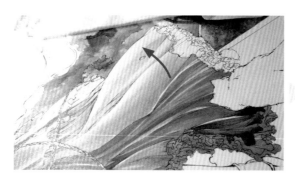

0 Colorless Blender — Blend everything using #0.

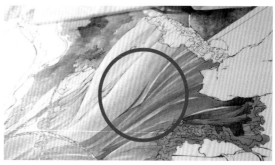

N5 Neutral Gray No.5 — Emphasize the dark parts created by the shadows of the creases.

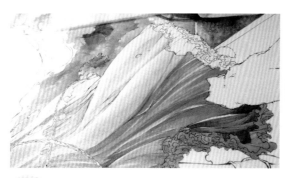

W1 Warm Gray No.1 — Apply W1 over the dark parts.

V01 Heath — Since a cherry blossom color faintly permeates this particular part of the dress, we need to apply V01 over everything.

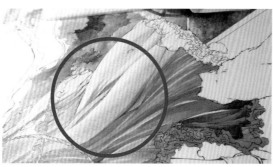

W1 Warm Gray No.1 — For the finishing touches, apply W1 in gradation over the indented areas on the bright plane.

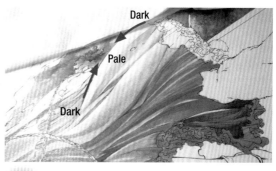

Dark

Pale

Dark

V01 Heath — Apply V01 in gradation towards the center of the shadow.

😷 Sliding Doors

This is a Japanese-style sliding door. It has a coarse texture that is easier to render with COPIC markers.

Here!

Before

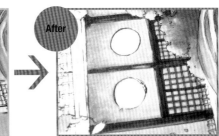

After

Color the Upper Half of the Sliding Doors

BV11
Soft Violet — Apply BV11 in a scratchy manner to create gradations.

B60
Pale Blue Gray — Fill the blank space with B60 as you pull down the ends of the previously applied BV11.

E43 Dull Ivory **E30** Bisque — Further apply colors as if lengthening the ink.

E30
Bisque — Neatly paint the edges of the flames.

RV10
Pale Pink — Lastly, apply RV10 to blend everything and complete.

▯ Undercolor the Lower Half of the Sliding Doors

E55 Light Camel — Undercolor the entire lower half, including the wooden frame.

V28 Eggplant — Apply V28 and blend in along the frame.

▯ Paint the Main Frame

E25 Caribe Cocoa — As for the outer frame, apply E25 vertically in layers leaving some white spaces.

Y26 Mustard **YR24** Pale Sepia — Paint as if filling white spaces that were left unpainted in the step above.

E27 Milk Chocolate — Apply E27 vertically for a shaded area. Be sure to soften the edge of the bright area.

Repeat these steps to complete the outer frame.

Point: **Basic Method for Painting Wood** Lay colors in one direction so they resemble growth rings.

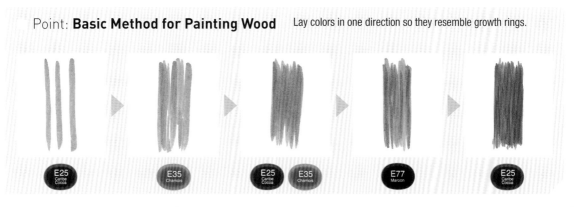

E25 Caribe Cocoa → E35 Chamois → E25 Caribe Cocoa E35 Chamois → E77 Maroon → E25 Caribe Cocoa

🎭 Morning Glow

Morning glow as seen through a half torn dome. This is the light that appears just between night and morning.

Here!

Before → After

⬚ Undercolor the Sky (Top)

B23 Phthalo Blue — After roughly painting the sky with B66, B18, and B95, paint the shadows of the cloud like tiger stripes.

BV11 Soft Violet — Extend BV11 in straight lines, always to the left, to create the shape of the clouds and shadows that spread horizontally.

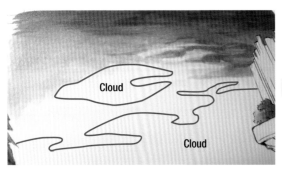

Cloud

Cloud

Y11 Pale Yellow — Draw morning light (Y11) reflected on the clouds.

BG72 Ice Ocean — Add BG72 to the sky in the same manner as where you laid Y11 and the colors of the upper sky. Maintain horizontal brush strokes.

Y11 Pale Yellow — Blend in the border between the blue and the light.

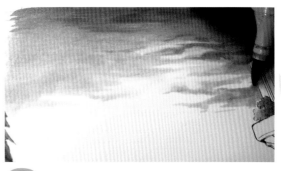

BG72 Ice Ocean — Add cloud shadows.

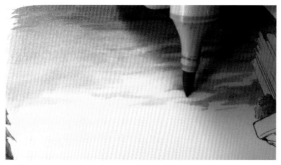

B01
Mint Blue

Draw the fine shapes of the clouds in the areas where Y11 was applied.

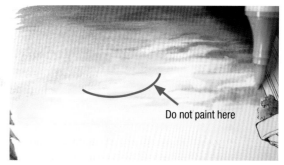

Do not paint here

Y11
Pale Yellow

Add light to the dark areas and overlay Y11 at the center of the sky.

Undercolor the Sky (Bottom)

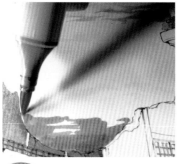

RV14
Begonia Pink

Apply RV14 while moving the brush both left and right.

E93
Tea Rose

Apply E93 as if layering.

RV32
Shadow Pink

Overlay RV32 while leaving a small portion of Y11.

V12
Pale Lilac

Further overlay V12 on the RV32.

YR15
Pumpkin Yellow

Add YR15 as if drawing clouds in the bright areas.

YR15
Pumpkin Yellow

Add depth to the shadows while blending.

V12
Pale Lilac

In between the night and morning sky, add V12 as you move the brush to the left and right.

YR15
Pumpkin Yellow

Blend in a color boundary.

V12
Pale Lilac

Blend in V12 where colors are not yet well blended.

Improving the Details of the Sky

E93
Tea Rose

Lay E93 in a way that makes the shape of the clouds distinctive.

YR15
Pumpkin Yellow

Blend the color that was applied. Do not blend the edge of the cloud.

RV32
Shadow Pink

Add shadows to the clouds that were made distinctive in the previous step.

BG72
Ice Ocean

Add blue (BG72) to the shadow of the cloud.

V12
Pale Lilac

Apply V12 to blend.

YR15
Pumpkin Yellow

Continue to draw clouds while blending with the background.

V12
Pale Lilac

Lay down some V12 wherever the depth of the clouds is lacking.

YR15
Pumpkin Yellow

Apply YR15 to blend.

Y11
Pale Yellow

Apply Y11 to blend further.

Finishing up the Clouds

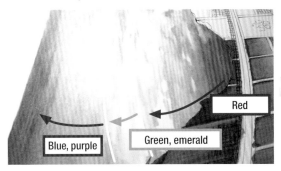

Red

Blue, purple

Green, emerald

In this particular case, pay attention to the fact that the colors of the cloud vary depending on their height.

BV11
Soft Violet

Beginning with the lower part, lay BV11 as if you were drawing cloud shadows.

BV11 Soft Violet — Lay down BV11 while blending in the neighboring colors.

Y15 Cadmium Yellow — Apply Y15 and blend in with the background. Repeat these steps to add more details.

B23 Phthalo Blue — **BV11** Soft Violet — The upper part has a blue base. Overlay B23.

BV11 Soft Violet — Lastly, blend in with the surrounding colors.

BG72 Ice Ocean — The middle section is a green base.

BV11 Soft Violet — Blend. Repeat these steps to finish painting the clouds.

▯ Finishing Touches

B23 Phthalo Blue — **BV11** Soft Violet — In order to bring out the depth of the sky, repeatedly apply the colors in a curved manner.

RV10 Pale Pink — Add redness to give off the impression of light to complete.

"COPIC Sketch"
Color Samples on Kent Paper

All 358 colors in "COPIC Sketch" applied on Kent paper make up this color sample.

When purchasing COPIC markers most people worry about what colors they should choose. You would think it best to choose a color by looking at the cap of the marker, but it often turns out that the color is not what you thought. Since COPIC markers use high transparency ink, the plastic cap is not capable of reproducing the exact color of the marker ink. Also, the color will look different depending on the absorbency of the paper. Having said that, for reference purposes, this section lists samples of colors that are actually applied on paper.

We elected to use Kent paper, which is popularly used for illustrations and manga. In addition, the sample lists the colors for single applications and double applications. Note that the second application is painted on after letting the first application dry.

* Since the color samples are printed, they may not show the colors as they actually are.
* The maker of COPIC, Too Marker Production Inc., uses PM paper as their standard.

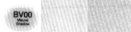

How to Use the Chart

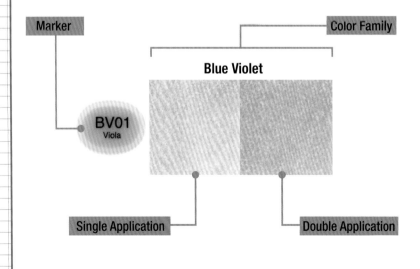

Marker

Color Family

Blue Violet

BV01
Viola

Single Application

Double Application

V – Violet

V0000 Rose Quartz
V95 Light Grape
V000 Pale Heath
V99 Aubergine
V01 Heath
V04 Lilac
V05 Azalea
V06 Lavender
V09 Violet
V12 Pale Lilac
V15 Mallow
V17 Amethyst
V20 Wisteria
V22 Ash Lavender
V25 Pale Blackberry
V28 Eggplant
V91 Pale Grape
V93 Early Grape

RV – Red Violet

RV0000 Evening Primrose
RV29 Crimson
RV000 Pale Purple
RV32 Shadow Pink
RV00 Water Lily
RV34 Dark Pink
RV02 Sugared Almond Pink
RV42 Salmon Pink
RV04 Shock Pink
RV52 Cotton Candy
RV06 Cerise
RV55 Hollyhock
RV09 Fuchsia
RV63 Begonia
RV10 Pale Pink
RV66 Raspberry
RV11 Pink
RV69 Peony
RV13 Tender Pink
RV91 Grayish Cherry
RV14 Begonia Pink
RV93 Smoky Purple
RV17 Deep Magenta
RV95 Baby Blossoms
RV19 Red Violet
RV99 Argyle Purple
RV21 Light Pink
RV23 Pure Pink
RV25 Dog Rose Flower

R – Red

R0000
Pink Beryl

R000
Cherry White

R00
Pinkish White

R01
Pinkish Vanilla

R02
Rose Salmon

R05
Salmon Red

R08
Vermilion

R11
Pale Cherry Pink

R12
Light Tea Rose

R14
Light Rouge

R17
Lipstick Orange

R20
Blush

R21
Sardonyx

R22
Light Prawn

R24
Prawn

R27
Cadmium Red

R29
Lipstick Red

R30
Pale Yellowish Pink

R32
Peach

R35
Coral

R37
Carmine

R39
Garnet

R43
Bougainvillaea

R46
Strong Red

R56
Currant

R59
Cardinal

R81
Rose Pink

R83
Rose Mist

R85
Rose Red

R89
Dark Red

YR – Yellow Red

YR0000
Pale Chiffon

YR000
Silk

YR00
Powder Pink

YR01
Peach Puff

YR02
Light Orange

YR04
Chrome Orange

YR07
Cadmium Orange

YR09
Chinese Orange

YR12
Loquat

YR14
Caramel

YR15
Pumpkin Yellow

YR16
Apricot

YR18
Sanguine

YR20
Yellowish Shade

YR21
Cream

YR23
Yellow Ochre

YR24
Pale Sepia

YR27
Tuscan Orange

YR30
Macadamia nut

YR31
Light Reddish Yellow

YR61
Spring Orange

YR65
Atoll

YR68
Orange

YR82
Mellow Peach

Y – Yellow

Y0000
Yellow
Fluorite

Y000
Pale Lemon

Y00
Barium
Yellow

Y02
Canary
Yellow

Y04
Acacia

Y06
Yellow

Y08
Acid
Yellow

Y11
Pale
Yellow

Y13
Lemon
Yellow

Y15
Cadmium
Yellow

Y17
Golden
Yellow

Y18
Lightning
Yellow

Y19
Napoli
Yellow

Y21
Buttercup
Yellow

Y23
Yellowish
Beige

Y26
Mustard

Y28
Lionet Gold

Y32
Cashmere

Y35
Maize

Y38
Honey

YG – Yellow Green

YG0000
Lily White

YG00
Mimosa
Yellow

YG01
Green Bice

YG03
Yellow
Green

YG05
Salad

YG06
Yellowish
Green

YG07
Acid
Green

YG09
Lettuce
Green

YG11
Mignonette

YG13
Chartreuse

YG17
Grass
Green

YG21
Anise

YG23
New Leaf

YG25
Celadon
Green

YG41
Pale Cobalt
Green

YG45
Cobalt
Green

YG61
Pale Moss

YG63
Pea Green

YG67
Moss

YG91
Putty

YG93
Grayish
Yellow

YG95
Pale Olive

YG97
Spanish
Olive

YG99
Marine
Green

G – Green

G0000 Crystal Opal		G28 Ocean Green
G000 Pale Green		G29 Pine Tree Green
G00 Jade Green		G40 Dim Green
G02 Spectrum Green		G43 Pistachio
G03 Meadow Green		G46 Mistletoe
G05 Emerald Green		G82 Spring Dim Green
G07 Nile Green		G85 Verdigris
G09 Veronese Green		G94 Grayish Olive
G12 Sea Green		G99 Olive
G14 Apple Green		
G16 Malachite		
G17 Forest Green		
G19 Bright Parrot Green		
G20 Wax White		
G21 Lime Green		
G24 Willow		

BG – Blue Green

BG0000 Snow Green		BG49 Duck Blue
BG000 Pale Aqua		BG53 Ice Mint
BG01 Aqua Blue		BG57 Jasper
BG02 New Blue		BG70 Ocean Mist
BG05 Holiday Blue		BG72 Ice Ocean
BG07 Petroleum Blue		BG75 Abyss Green
BG09 Blue Green		BG78 Bronze
BG10 Cool Shadow		BG90 Gray Sky
BG11 Moon White		BG93 Green Gray
BG13 Mint Green		BG96 Bush
BG15 Aqua		BG99 Flagstone Blue
BG18 Teal Blue		
BG23 Coral Sea		
BG32 Aqua Mint		
BG34 Horizon Green		
BG45 Nile Blue		

B – Blue

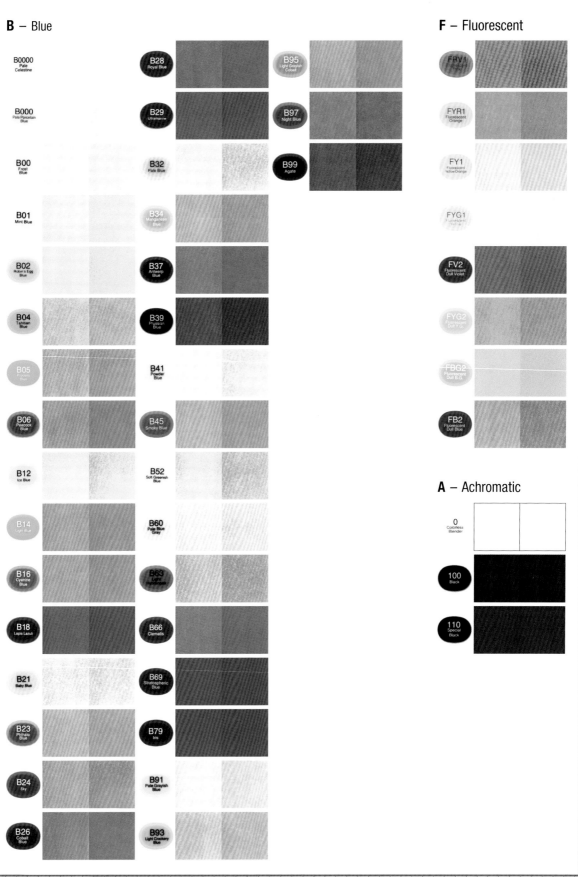

B0000 Pale Celestine	B28 Royal Blue	B95 Light Grayish Cobalt
B000 Pale Porcelain Blue	B29 Ultramarine	B97 Night Blue
B00 Frost Blue	B32 Pale Blue	B99 Agate
B01 Mint Blue	B34 Manganese Blue	
B02 Robin's Egg Blue	B37 Antwerp Blue	
B04 Tahitian Blue	B39 Prussian Blue	
B05 Process Blue	B41 Powder Blue	
B06 Peacock Blue	B45 Smoky Blue	
B12 Ice Blue	B52 Soft Greenish Blue	
B14 Light Blue	B60 Pale Blue Gray	
B16 Cyanine Blue	B63 Light Hydrangea	
B18 Lapis Lazuli	B66 Clematis	
B21 Baby Blue	B69 Stratospheric Blue	
B23 Phthalo Blue	B79 Iris	
B24 Sky	B91 Pale Grayish Blue	
B26 Cobalt Blue	B93 Light Crockery Blue	

F – Fluorescent

FRV1 Fluorescent Pink	
FYR1 Fluorescent Orange	
FY1 Fluorescent Yellow Orange	
FYG1 Fluorescent Yellow	
FV2 Fluorescent Dull Violet	
FYG2 Fluorescent Dull Y.G.	
FBG2 Fluorescent Dull B.G.	
FB2 Fluorescent Dull Blue	

A – Achromatic

0 Colorless Blender	
100 Black	
110 Special Black	

E – Earth

E0000
Floral White

E000
Pale Fruit Pink

E00
Cotton Pearl

E01
Pink Flamingo

E02
Fruit Pink

E04
Lipstick Natural

E07
Light Mahogany

E08
Brown

E09
Burnt Sienna

E11
Barely Beige

E13
Light Suntan

E15
Dark Suntan

E17
Reddish Brass

E18
Copper

E19
Redwood

E21
Soft Sun

E23
Hazelnut

E25
Caribe Cocoa

E27
Milk Chocolate

E29
Burnt Umber

E30
Bisque

E31
Brick Beige

E33
Sand

E34
Toast

E35
Chamois

E37
Sepia

E39
Leather

E40
Brick White

E41
Pearl White

E42
Sand White

E43
Dull Ivory

E44
Clay

E47
Dark Brown

E49
Dark Bark

E50
Egg Shell

E51
Milky White

E53
Raw Silk

E55
Light Camel

E57
Light Walnut

E59
Walnut

E70
Ash Rose

E71
Champagne

E74
Cocoa Brown

E77
Maroon

E79
Cashew

E81
Ivory

E84
Khaki

E87
Fig

E89
Pecan

E93
Tea Rose

E95
Tea Orange

E97
Deep Orange

E99
Baked Clay

C – Cool Grey **N** – Neutral Grey **T** – Toner Grey **W** – Warm Grey

C00
Cool Gray
No.00

W00
Warm Gray
No.00

C0
Cool Gray
No.0

N0
Neutral Gray
No.0

T0
Toner Gray
No.0

W0
Warm Gray
No.0

C1
Cool Gray
No.1

N1
Neutral Gray
No.1

T1
Toner Gray
No.1

W1
Warm Gray
No.1

C2
Cool Gray
No.2

N2
Neutral Gray
No.2

T2
Toner Gray
No.2

W2
Warm Gray
No.2

C3
Cool Gray
No.3

N3
Neutral Gray
No.3

T3
Toner Gray
No.3

W3
Warm Gray
No.3

C4
Cool Gray
No.4

N4
Neutral Gray
No.4

T4
Toner Gray
No.4

W4
Warm Gray
No.4

C5
Cool Gray
No.5

N5
Neutral Gray
No.5

T5
Toner Gray
No.5

W5
Warm Gray
No.5

C6
Cool Gray
No.6

N6
Neutral Gray
No.6

T6
Toner Gray
No.6

W6
Warm Gray
No.6

C7
Cool Gray
No.7

N7
Neutral Gray
No.7

T7
Toner Gray
No.7

W7
Warm Gray
No.7

C8
Cool Gray
No.8

N8
Neutral Gray
No.8

T8
Toner Gray
No.8

W8
Warm Gray
No.8

C9
Cool Gray
No.9

N9
Neutral Gray
No.9

T9
Toner Gray
No.9

W9
Warm Gray
No.9

C10
Cool Gray
No.10

N10
Neutral Gray
No.10

T10
Toner Gray
No.10

W10
Warm Gray
No.10

How to render eye-catching textures with COPIC markers!
by Midorihana Yasaiko

Text and images copyright © 2016 Midorihana Yasaiko and Graphic-sha Publishing Co., Ltd.
COPIC® is a registered trademark of Too Corporation, Japan.

First designed and published in Japan in 2016 by Graphic-sha Publishing Co., Ltd.

English edition published in the United States of America in 2018 by Schiffer Publishing, Ltd.

"Schiffer," "Schiffer Publishing, Ltd.," and the pen and inkwell logo are registered
trademarks of Schiffer Publishing, Ltd.

Published by Schiffer Publishing, Ltd.
4880 Lower Valley Road
Atglen, PA 19310
Phone: (610) 593-1777; Fax: (610) 593-2002
E-mail: Info@schifferbooks.com
www.schifferbooks.com

ISBN 978-0-7643-5611-7

Library of Congress Control Number: 2018934618

First English Edition: September 2018

Printed in China

10 9 8 7 6 5 4 3 2 1

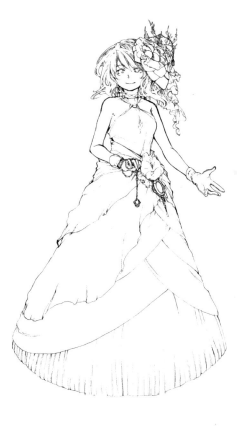

Original creative staff

Art direction:	Hiromi Adachi (Adachi Design Laboratory)
Book design:	Hiroki Higa (Higa Design Office)
Photos:	KazushigeTakashima (COLORS)
Screen image production:	Nakarai
Editorial collaboration:	Kouji Matsumura
Cooperation:	Too Marker Products Inc.
Equipment:	Tajima Motor Corporation Co., Ltd.,
	Blue Current Japan Co., Ltd.
Planning and editing:	Akira Sakamoto (Graphic-sha Publishing Co., Ltd.)

English edition

English translation:	Kevin Wilson
English edition layout:	Shinichi Ishioka
Editing:	Peggy Kellar (Schiffer Publishing, Ltd.)
Production and management:	Kumiko Sakamoto (Graphic-sha Publishing Co., Ltd.)